IMAGES
of America

VINALHAVEN ISLAND

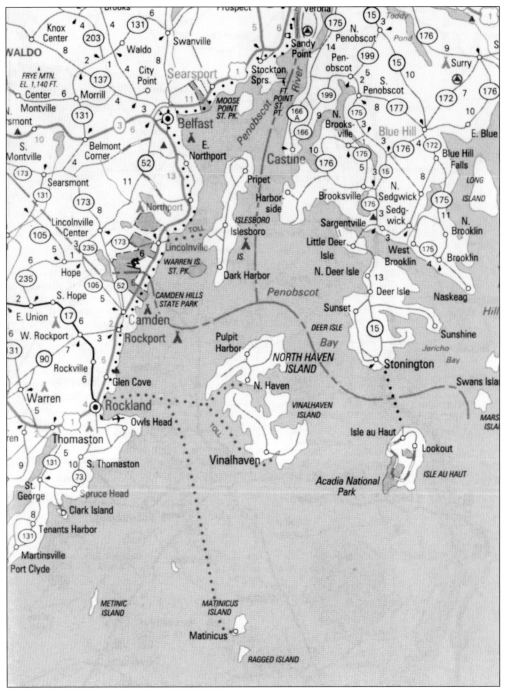

A map showing Vinalhaven Island and the surrounding area. (© AAA reproduced by permission.)

IMAGES
of America

VINALHAVEN
ISLAND

The Vinalhaven Historical Society

ARCADIA

Copyright © 1997 by The Vinalhaven Historical Society
ISBN 0-7385-4524-4

Published by Arcadia Publishing
Charleston SC, Chicago IL, Portsmouth NH, San Francisco CA

Printed in the United States of America

Library of Congress Catalog Card Number: 2006922341

For all general information contact Arcadia Publishing at:
Telephone 843-853-2070
Fax 843-853-0044
E-mail sales@arcadiapublishing.com
For customer service and orders:
Toll-Free 1-888-313-2665

Visit us on the internet at http://www.arcadiapublishing.com

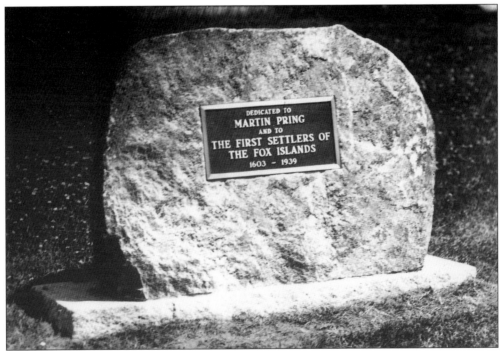

This plaque was dedicated during the island's sesquicentennial celebration in 1939. Martin Pring, an English sea captain, is credited with the naming of the Fox Islands, the present Vinalhaven and North Haven, during his voyage in 1603.

Contents

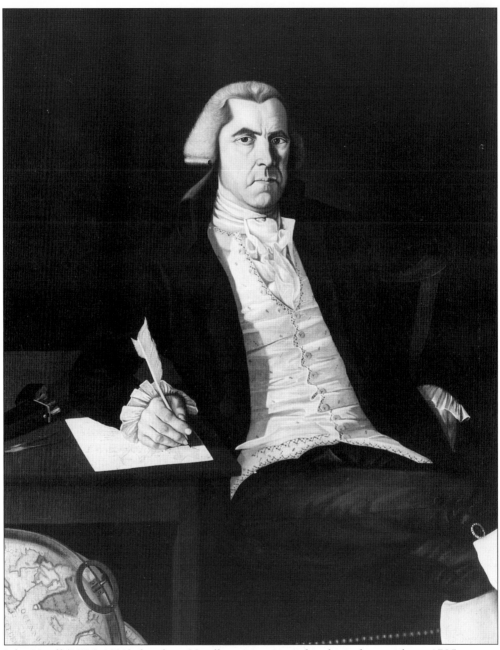

John Vinall (1736–1823), for whom Vinalhaven was named, is shown here in this c. 1785 portrait by John Mason Furness. He was a Bostonian, a "man of influence," a teacher, a merchant, and an attorney. His son William had settled in the Fox Islands. When the inhabitants of the islands petitioned the General Court of Massachusetts for title to their lands, John was their attorney. North and South Fox Islands were incorporated as the town of Vinalhaven on June 25, 1789.

Introduction

Vinalhaven Island's history has been shaped by its location on New England's earliest highway, the sea. The first known visitors were the Red-Paint people who came 3,800 to 5,000 years ago; by the 1600s, the Abenakis were here, and the area was visited by European explorers. The first permanent settlement was by English colonists in the 1760s following the end of the French and Indian War. After the Revolutionary War, the population grew rapidly, and by 1800, the combined population of North and South Fox Islands was 860. In 1846, North Island was "set off" to become North Haven, and by 1880, the population of South Island, Vinalhaven, reached its peak of 2,855.

The early occupations were fishing, farming, logging, and shipbuilding. By 1826, the quality of Vinalhaven's granite was discovered, and the island's one hundred-year period as one of Maine's largest quarrying centers began. Joining the island families were men from other states, from Canada, Scotland, England, Ireland, and later from Scandinavia. Hundreds of men quarried, cut, polished, and carved many tons of granite. Stone left the island on sloops, schooners, and barges for ports as far away as New Orleans and Pensacola. The first large federal government contracts were for stone to reinforce gun platforms at forts along the Atlantic and Gulf coasts prior to the Civil War. After the war, when the government wanted to build grandiose, European-style buildings, granite was chosen as a primary building material, not just for its durability but also because it could be carved to create an elaborate Beaux-Arts style of decoration. Granite went to build such structures as U.S. custom houses and post offices in New York City, Kansas City, and Buffalo; railroad stations in Chicago and Philadelphia; and federal office buildings in Washington, D.C., as well as thousands of tons of curbing and paving blocks for many other cities. With the advent of concrete and structural steel as building materials and the subsequent change in architectural styles, the largest granite company closed in 1919. However, the paving block industry continued until the late 1930s.

This book is not intended to be a comprehensive history but rather seeks to make accessible a photographic record of various aspects of island life from the period between 1860 and 1960, with special emphasis on the period between 1870 and 1920. Some aspects are not included because we did not have the images or, as is the case of the summer colony which started in 1885 on the Thorofare, they have appeared in recent publications. The primary focus of the book is the island's commercial, social, and population center at Carver's Harbor on the southern shore, a 15-mile boat trip from the mainland. Most of the photographs are from the Vinalhaven Historical Society's collection of ferrotypes, stereoscopic views, glass-plate negatives, and prints,

7

including 580 glass plates by Merrithew which date back to 1890. A number are being published here for the first time. Others have appeared in Ivan Calderwood's nostalgic books of island life, now out of print.

The island had four native-born, professional photographers: Charles B. Vinal (1824–1892), William V. Lane (1849–1903), Frank H. Winslow (1863–1943), and William H. Merrithew (1871–1940). Also, James P. Armbrust (1844–1919) came to the island in the 1870s as a "Railroad and Mechanical Photographer." Lane was the teacher of both Winslow and Merrithew and had studios on the island and on the mainland in Camden.

This book's historical information has been gathered from many sources, including town records, O.P. Lyons' A Brief Historical Sketch of Vinalhaven (1889, updated by Albra Vinal in 1900), Sidney L. Winslow's weekly newssheets The Neighbor (1937–1939) and Fish Scales and Stone Chips (1952), and Roger L. Grindle's Tombstones and Paving Blocks (1977). Vinalhaven Reminiscences (1978), compiled by Athene Anthony, also provided valuable oral histories.

Photographs can give a sense of the history of a community and its human dimensions. We hope these will be of interest to Vinalhaven's families, friends, and visitors as part of our ongoing effort to understand and preserve the island's rich past. We also hope that readers will tell us about any errors we have made in the text or additional information that should be added to the society's records.

Esther Jones Bissell
Roy V. Heisler
February 1997

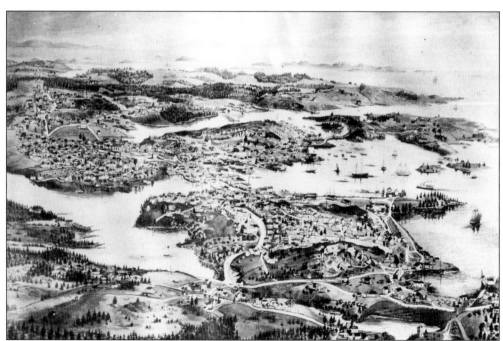

In the late 1800s, a number of men worked as "view artists," doing detailed drawings of various communities. This "Bird's Eye View" of the town of Vinalhaven was done by George E. Norris in 1893. The picture was probably printed by a photo-reproduction process after Norris' watercolor drawing.

One

Carver's Harbor: 1860s and 1870s

One of the earliest photographs of Carver's Harbor, this image was taken in the 1860s.

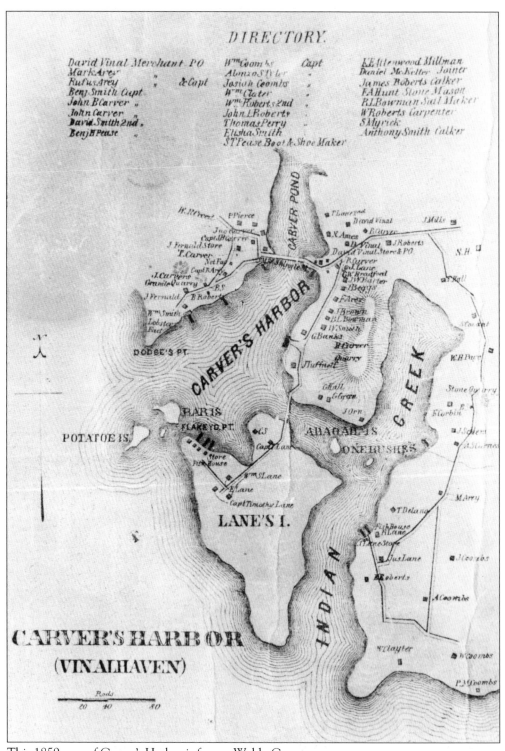

This 1859 map of Carver's Harbor is from a Waldo County map.

10

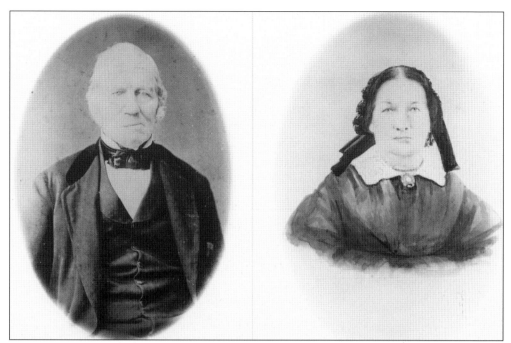

John Carver (1793–1877) was the son of Thaddeus Carver, one of the earliest settlers who arrived from Marshfield, Massachusetts, in 1766 and purchased 700 acres around "Carver's Harbor" in 1776. John was engaged in fishing and coasting and was prominent in town affairs as a selectman and state representative. He and Rhoda Arey (1800–82) were married in 1818 and had thirteen children. The John Carver Homestead, shown in this fanciful drawing, was built by his father, Thaddeus Carver, in about 1790.

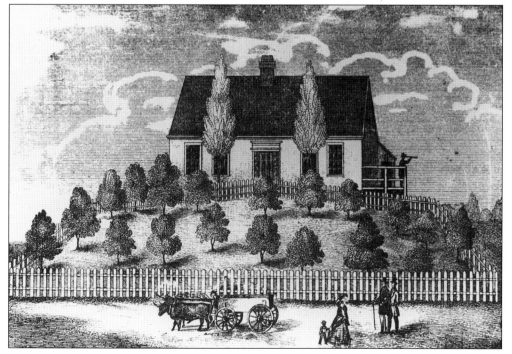

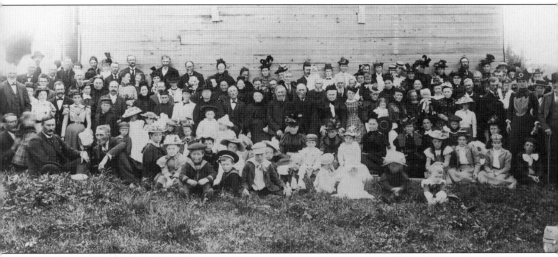

Another important family, the Calderwoods, settled on the northeast part of the island, now known as Calderwood's Neck. Farmers and fishermen, they took an active role in the affairs of the town. Three of the Calderwood patriarchs are shown below at the time of a family reunion about 1889.

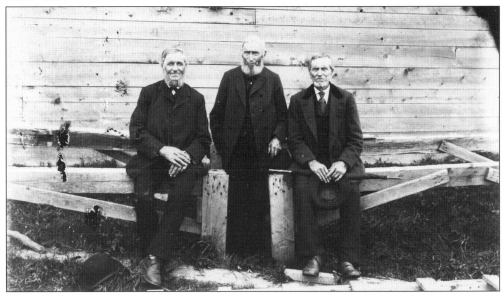

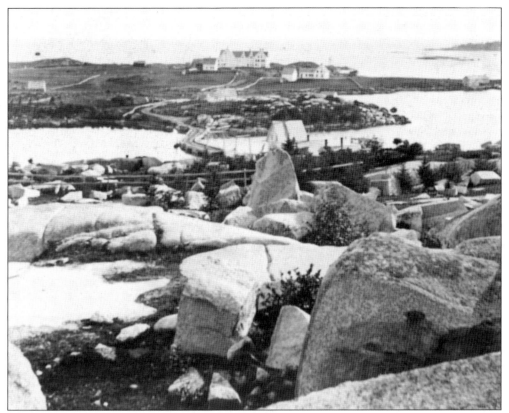

This stereoscopic view of Lane's Island was probably taken in the late 1860s. Benjamin Lane (1762–1842) bought the island from Thaddeus Carver. Benjamin's son Timothy (1805–1871) built the "big house," constructed two additional homes for his sons, and established a successful business curing fish and outfitting fishing vessels. The view below, from the same era, shows the home of Timothy and Rebecca Smith Lane. The extent of Timothy's property made him the largest taxpayer in town in 1865.

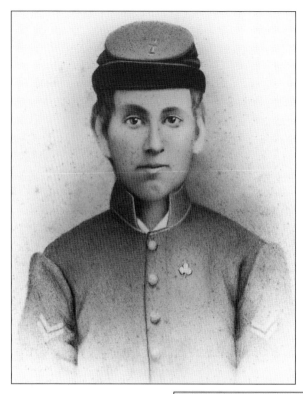

Woster S. Vinal was born to David and Mary Arey Vinal in 1844. On August 25, 1862, he joined the Union Army to serve in Company I of the 19th Regiment of Maine Volunteers. This remarkable image, a crayon portrait, was found inside his tin-type picture in the island's GAR collection. Woster was a prisoner at Andersonville, and his father received letters from Clara Barton as to his whereabouts.

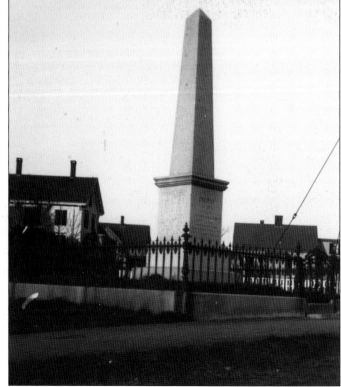

The Civil War Monument was erected in 1870. The records of the GAR (Grand Army of the Republic), an organization of veterans of the Civil War, show that 172 men from the island's population of 1,667 served in the war, with 23 deaths.

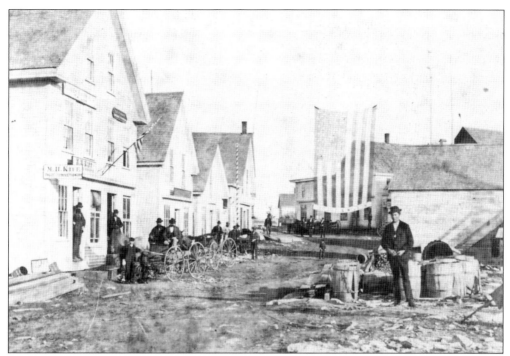

This stereoscopic view of Main Street was taken in 1872 during a presidential election campaign. The banner extols the candidacy of Republican Ulysses S. Grant and his running mate, Henry Wilson.

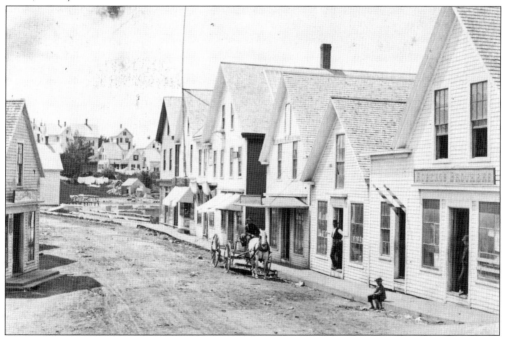

Here we see Main Street before the western end was built up, as well as homes on the hill. The Roberts Brothers' building was the site of a netting business and had a barber shop in its extension.

This 1871 stereoscopic view from behind Main Street looks east across Carver's Pond to the homes on Chestnut Street. The boys are sitting near where the Odd Fellows building would later stand.

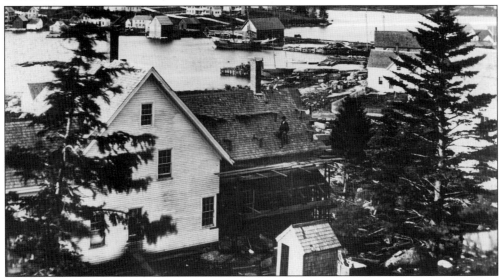

This view, also from the early 1870s, looks northwest across the harbor from Kittredge/Armbrust Hill. As yet, only a narrow passage has been erected across the millstream. The building on the left was the grain mill with tidal-powered grinding wheels.

Two

Granite by the Sea

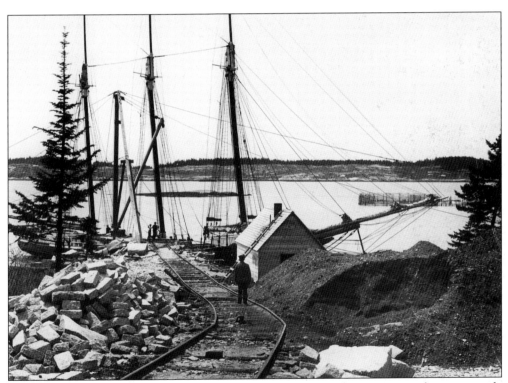

The proximity of Vinalhaven's granite quarries to the primary shipping route, the sea, is made clear in this picture of a small hillside quarry. The paving blocks cut here were carried by gravity to the shipping wharf in small rail cars that were hauled back up the hill by horses. To the right of the quarry is a large fish weir, an indication of the island's other major industry.

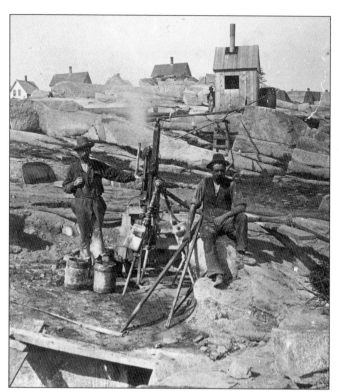

In the 1870s, drills for making holes in granite were driven by steam, as shown in this early picture of Harbor Quarry. The opening date of the quarry, on the northwest side of Carver's Harbor, is not known; however, it was re-opened by Bodwell & Webster Co. in 1853 and remained active until the mid-1880s.

By 1860, Bodwell & Webster (later the Bodwell Granite Co.) had acquired the area known as Sands Quarry, near Sands Cove off Carver's Harbor, and started extracting, cutting, and carving large quantities of granite.

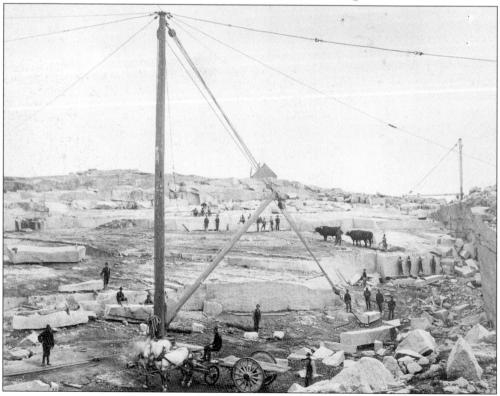

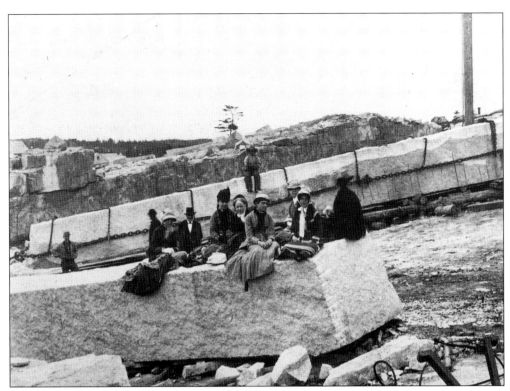

In 1878, a 75-foot monolith was taken from Sands Quarry to be cut as a monument for General John E. Wool. At the time, it was believed to be the largest piece of stone ever quarried in the United States, weighing 650 tons with its foundations . The first piece was discarded because of a flaw and thus provides a place for the visitors to picnic.

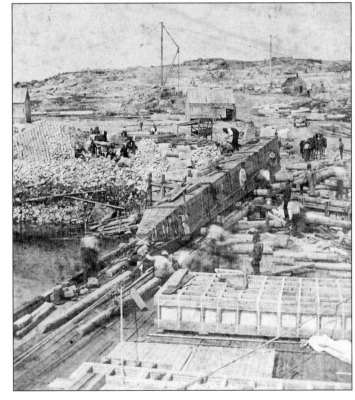

The completed Wool Monument was crated and placed aboard the barge *Jemima Leonard* and then towed by the tug *Knickerbocker* from the Sands wharf to Troy, New York, on August 16, 1879.

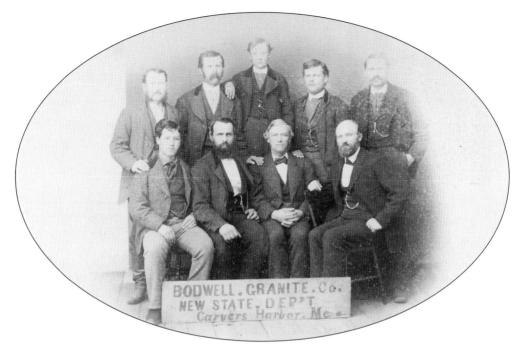

The man seated third from the left is Moses Webster, a very important figure in the business and social affairs of the island. A native of Pelham, New Hampshire, he came here in 1851 to pursue a career in the granite industry. Along with Joseph R. Bodwell, from Methuen, Massachusetts, Mr. Webster built the Bodwell Granite Co. into one of the country's largest granite companies. It dominated the economic life of the island and was the primary employer from 1871 to 1910.

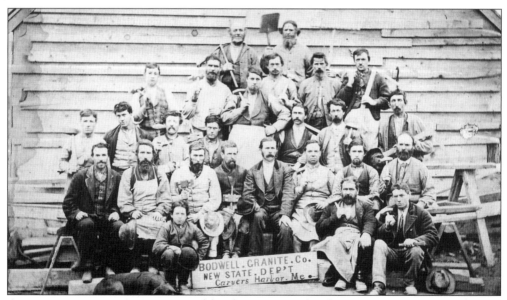

A government contract was received by the company for the "new" State, War, and Navy Building next to the White House in Washington, D.C. A major contract, it kept many men busy for much of 1872–88. Some of the men, stone cutters and apprentices, are shown here with their tools. They joined the first Granite Cutters National Union when it was formed in 1877.

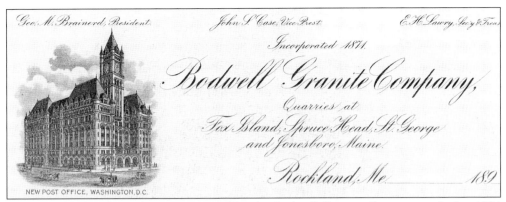

Geo. M. Brainerd, President. John S. Case, Vice Prest. E. H. Lawry, Sec'y & Treas.

Incorporated 1871.

Bodwell Granite Company,

Quarries at

Fox Island, Spruce Head, St. George and Jonesboro, Maine.

Rockland, Me. _____ 189_

NEW POST OFFICE, WASHINGTON, D.C.

This letterhead, one of the many printed by the Bodwell Granite Co., was used after 1894 when the Washington, D.C. Post Office (pictured) was completed. The company's office was in Rockland. By this time, both Joseph Bodwell and Moses Webster had died.

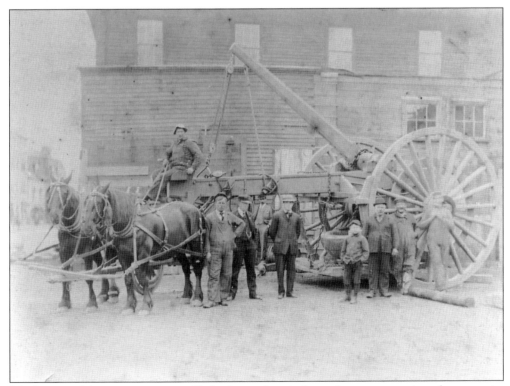

The largest of the stone wagons, called galamanders, is shown here transporting a huge granite bowl to the polishing mill on Main Street. The mill stood over the stream between Carver's Harbor and the pond.

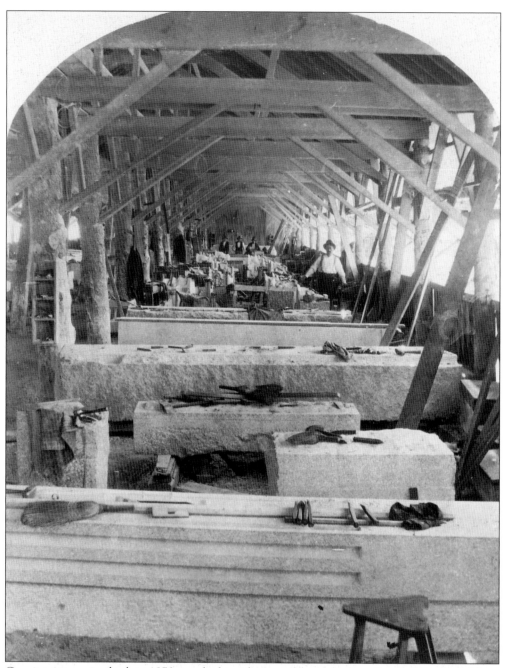

Granite carvers in the late 1870s worked inside several long sheds at Sands Stoneyard. Here, the stone for various jobs is shown with the carver's chisels, hammers, and other tools at their work stations.

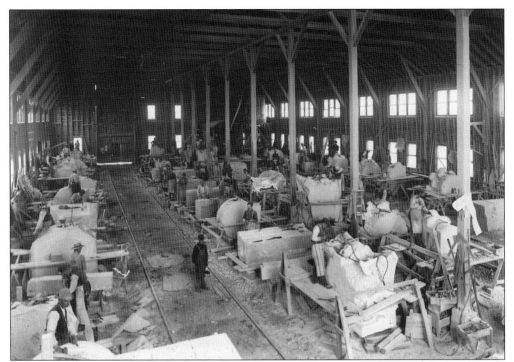

In about 1903, 140 carvers were at work on the decorations for the U.S. Custom House in New York City. Many of them can be seen working inside the "Big Shed" at the stoneyard.

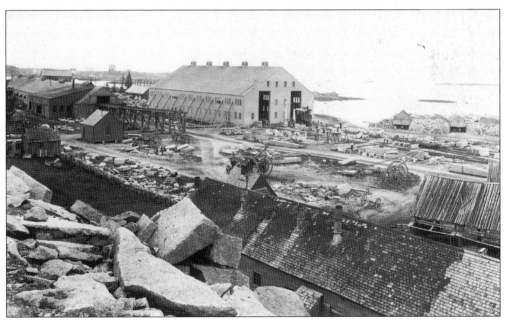

This 1907 image of the stoneyard gives some idea of the size of the operation, showing the "Big Shed," the blacksmith shop, various cutting sheds, storehouses, and work areas for the paving cutters on the shore of Sands Cove. Stone quarried on the island and at other quarries in Maine was brought here to be finished.

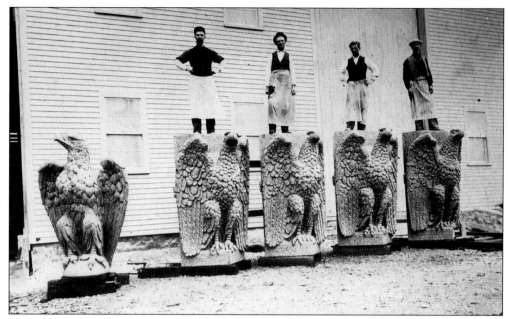

From 1896 to 1898, stonecutters worked on the Buffalo, New York, Post Office. Five eagles were carved by Robert Whyte, Charles Athearn, Her`bert Clarke, and Elbridge Rolfe. Whyte recorded that it took 150 working days to carve his eagle. A story goes that a lady visitor asked how in the world did the men do it and was told, "Oh, there's nothing to it, Ma'am, for the eagle was already in the stone and all I had to do was to let him out."

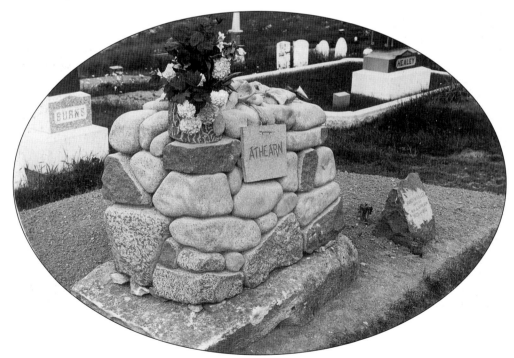

This monument for his family at Carver's Cemetery was carved from a single block of granite by Charles Athearn, one of Vinalhaven's most skilled carvers.

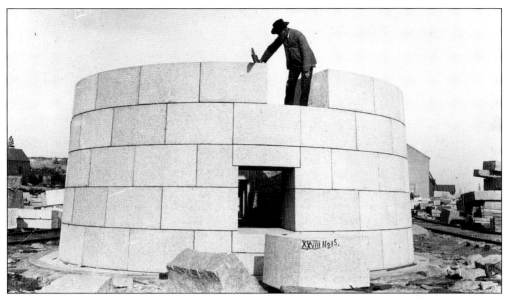

Edward Russell Jr., superintendent of the Sands Stoneyard after the retirement of John Lowe in 1899, is shown here checking and marking the blocks for Ram Island Ledge Light in Casco Bay. After the blocks were crated, they were shipped to Portland aboard the stone sloops *Yankee Girl* and *M.M. Hamilton*.

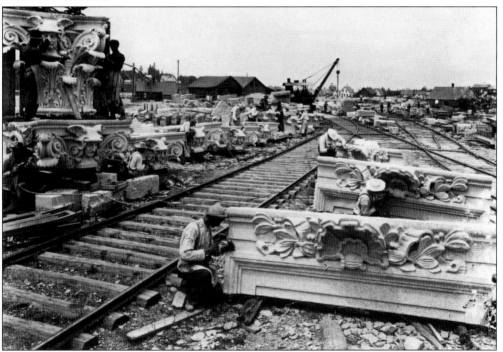

Carvers here are putting the finishing touches on work for the U.S. Custom House, an imposing Beaux-Arts building completed in 1907 in New York City. The men on the left are working on some of the capitals for the 44 three-story columns which surrounded the building; each one contained an image of Mercury, the god of commerce. On the right are lintels for the windows on the fourth story.

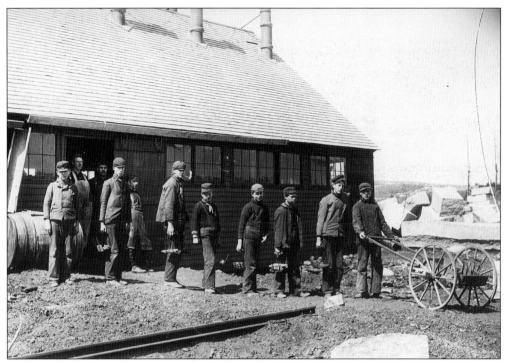

Many boys, often as young as thirteen, started their apprenticeships in the granite industry earning 50¢ a day for carrying tools to be sharpened from the carvers and quarrymen to the blacksmiths' shop. On one day in January 1889, it was reported that the blacksmiths sharpened 1,743 drills.

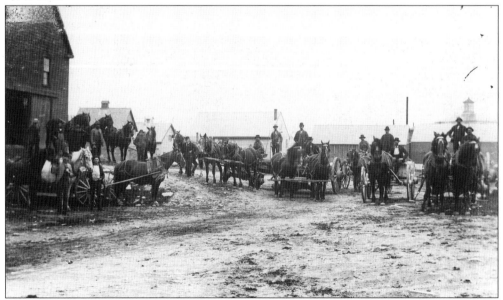

Stone was moved on wooden rollers and on stone carts, or by galamanders which were pulled at first by oxen and later by teams of horses. This photograph was taken outside the Bodwell Company barn, where horses and teamsters wait to start their day working in the quarry. The men were "proud of their teams and kept horses well groomed and their harnesses gleaming."

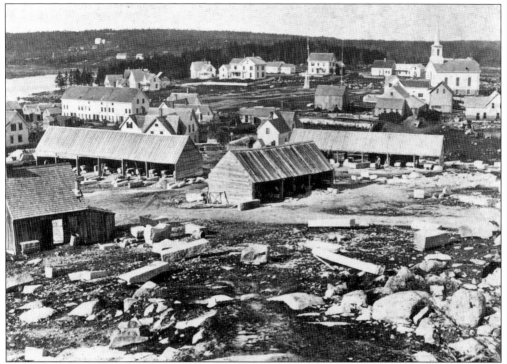

This image, from the early 1870s, shows the stone sheds of the Kittredge/Armbrust Hill Quarry. It also gives an excellent view of the east side of town with the Union Church, the Civil War Monument, and the David Vinal and Reuben Carver homesteads.

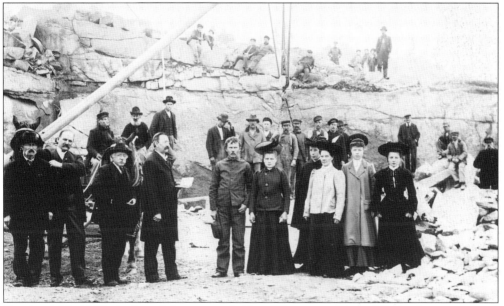

On April 21, 1905, Andrew Lakstrom and Alma Watame, natives of Finland, were married at the quarry on Armbrust Hill by Elder William Strout. Shown with the couple are James P. Armbrust (the owner and operator of the quarry), other quarry officials, quarry workers, friends, and curious bystanders.

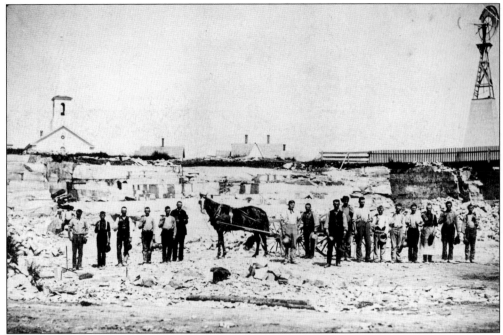

In the late 1870s, Joseph S. Black, who came from Aberdeen, Scotland, in 1871, started a paving quarry in the town at what later was called Net Factory Hill. The quarry had to be discontinued because of its proximity to Main Street.

The A.M. Webster Quarry on Pleasant River, which existed from 1900 to 1908, with Charles Chilles from Scotland as superintendent, was also the site of the construction of the three-masted schooner *Margaret M. Ford* in 1904.

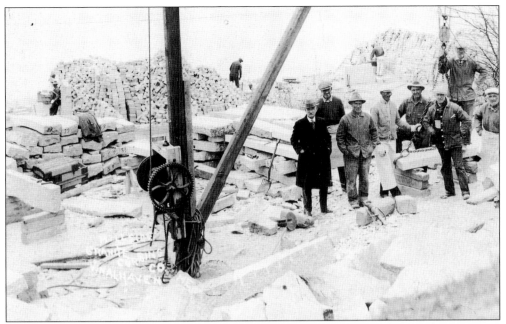

Joseph Black, in the dark coat, is shown here directing the cutting of curbing at the quarry, on the western end of Carver's Pond in 1897.

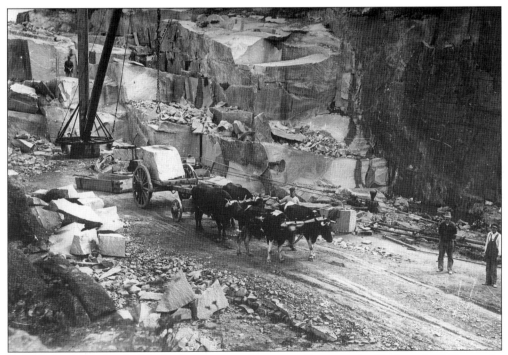

Two yoke of oxen haul a block of granite weighing over 5 tons at the Dushane Hill Quarry. In the early years, as many as one hundred yoke of gentle, patient oxen furnished the power to operate the derricks and to haul stone to the cutting yards and the shipping wharfs. Maintaining the animals required many shipments of hay.

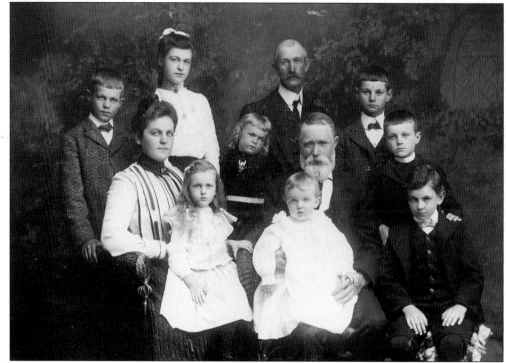

Edward Russell Sr. is shown here in 1904 with his son "Eddie," daughter-in-law May, and eight of his nine grandchildren. Edward came to Maine from Ireland to work in the granite business as an agent for the Bodwell Granite Company and as superintendent of Wharff's Quarry.

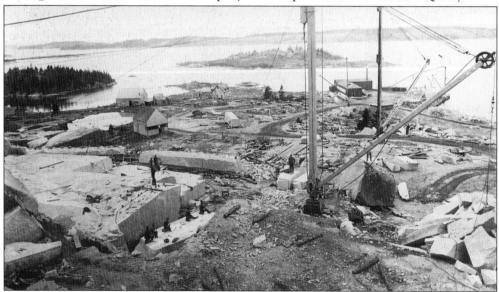

From 1899 through 1904, Wharff's Quarry, named for George Wharff, was the site of one of the country's major quarrying feats. The huge columns for the Cathedral of Saint John the Divine in New York City were quarried, shaped, turned, and polished here. Two of the large pieces already taken from the quarry bed are waiting to be hauled down the hill to the shed at the water's edge.

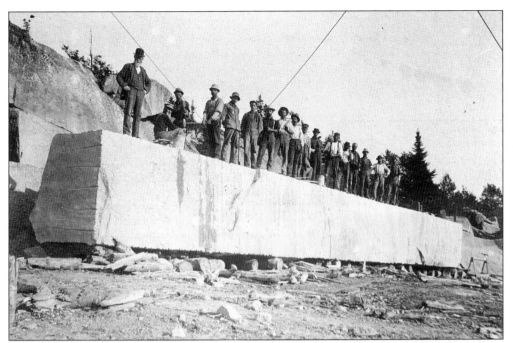

In 1899 and for the next few years, there was much press coverage of the cathedral job. *Stone Trade News* ran this Will Merrithew picture of Ed Russell with sixteen of the quarrymen and cutters standing on one of the rough blocks 64 feet long, 8 feet wide, and 7 feet thick.

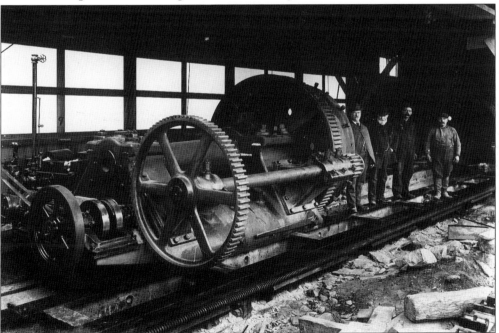

The largest granite cutting lathe in 1900 was designed by E.R. Cheney of Boston for the cutting of the columns, and was set up at Wharff's Quarry. The 135-ton lathe had eight cutters and cost $50,000. Because of their great length and weight, the columns had to be made in two sections, which were 36 and 18 feet long and 90 and 40 tons, respectively.

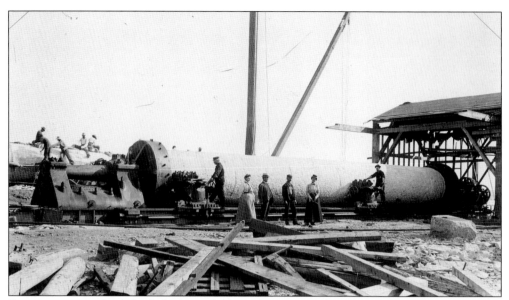

Excitement over the cathedral job was high, and visitors to the quarry were many. Most of the workers lived in a dormitory at the site, but the visitors and photographers had to travel at least 5 miles from town by land or come by boat. Behind the lathe in this picture, men are hand-cutting a column to prepare it for the lathe.

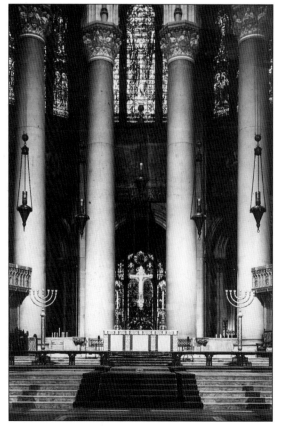

As this interior view of the cathedral shows, the columns behind the altar are an impressive sight. They were erected in 1904, and the cathedral was built around them.

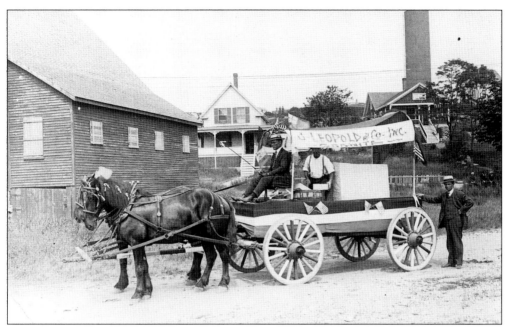

J. Leopold & Company worked at the "East Boston" quarry from 1909 until 1931 and was the major shipper of paving blocks. The wagon above was built for a Fourth of July parade, with teamster Miles Sukeforth driving paving cutter Alfred Brown. Charles Chilles, superintendent for Leopold, stands behind. After the demand for granite as a building material waned, J. Leopold & Company became the largest employer of granite workers, as the 1914 photograph below suggests.

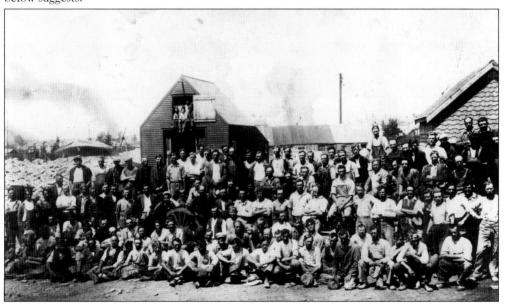

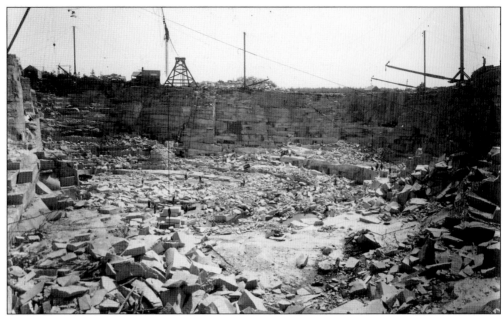

The big pit at "East Boston" in about 1915 was a busy place, with men and equipment working at various stages of quarrying. The large 60-foot tower, one of a two-tower set called a Blondin, had two 3/4-inch wire cables which stretched 800 feet across the quarry. This system was a very efficient way of moving heavy blocks out of the quarry pit. Water, which would eventually fill the quarry when it was abandoned in 1931, can be seen here as dark spots on the quarry wall.

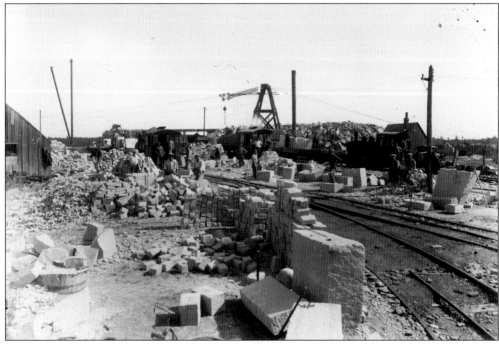

Each of the paving cutters had his own work space, called a "berth." The final shaping of the stone was done with a hammer and chisel on the tub of "grout," after the block had been split from a bigger piece.

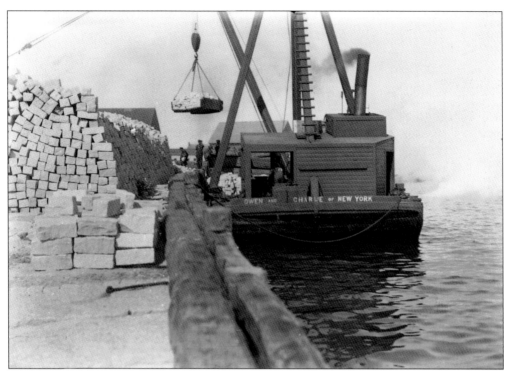

Many tons of paving blocks were taken to the shipping wharf, where they were loaded on the lighter *Owen & Charlie*, as shown here in 1915. They were then towed through Indian Creek to the wharf on Carver's Harbor, a trip which could only take place at high tide.

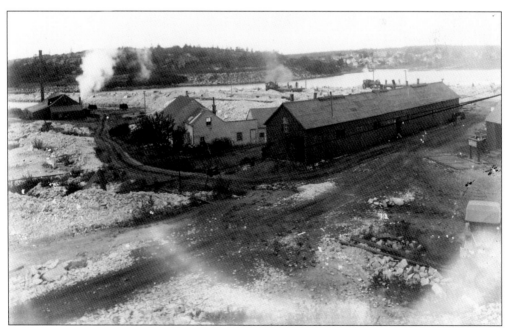

A 1919 town meeting voted to allow the Leopold Company to build a bridge across Indian Creek and lay tracks so that the locomotives could carry the blocks directly to the harbor wharf.

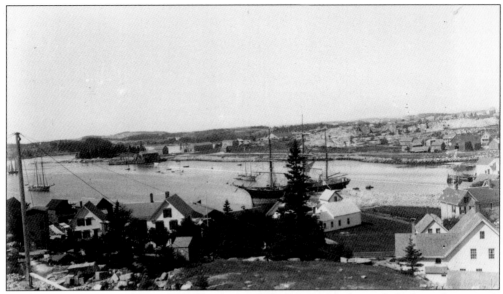

This view from the Armbrust Hill Quarry in 1904 shows an Italian salt bark at the quarry's wharf, where paving blocks were stacked on the dock. Across the harbor can be seen Harbor Quarry, Bodwell's Horse and Hay Barn, the Steamer Wharf, and Sands Stoneyard.

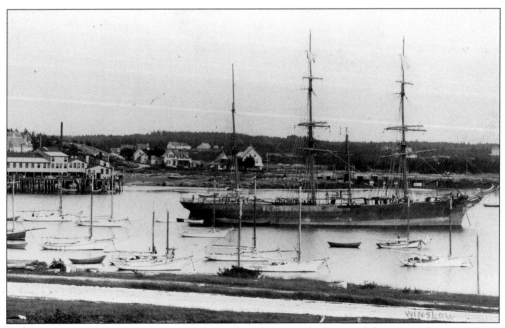

By 1903, Lane-Libby's Vinalhaven Fish Co. had become the largest fish curing plant in Maine and one of the largest in the country. It handled between 7 and 8 million pounds of fish, employing one hundred people in the factory and two hundred or more on the boats. The company built a large bonded salt warehouse, with a capacity of 3,000 hogsheads, and imported salt directly from Europe. One of the shipments arrived aboard this Italian bark.

Three

Fish and Ships

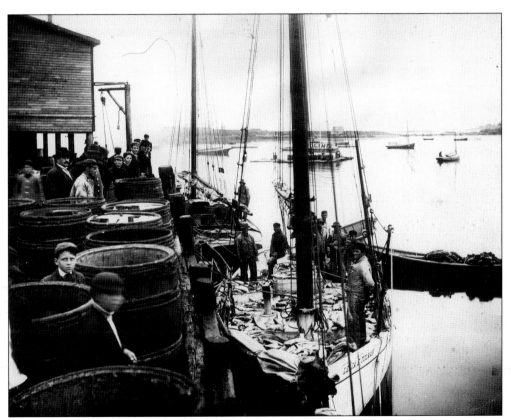

The large fishing sloop *Lelia E. Tolman*, with Captain Walter T. Tolman in the bow, is shown here at the dock in about 1910. Captain Tolman's catches of cod, hake, and pollock were an important part of Lane-Libby Fisheries' success. When the boats came in from the fishing banks, a crowd would welcome them home.

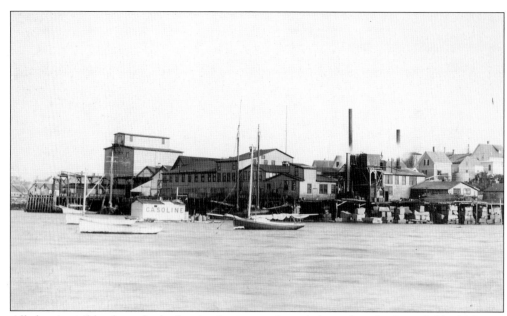

All that is visible along the harbor in the image above belonged to the Lane-Libby Fisheries Company. The tall building on the left was their cold storage plant, the first of its kind on the East Coast. By 1910, the company was curing and freezing fish, manufacturing glue and fertilizer, producing cod liver oil and other by-products, and importing and selling salt for curing fish. The lower image shows how extensive the fish-curing business, started in 1878, had become by the end of the 1890s.

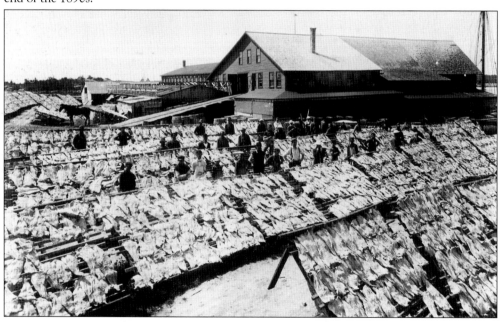

In 1908, the company was reorganized, and shares of common and preferred stock were issued. The company's trademark, the osprey, was the symbol used for Osprey Brand products, such as the "Pure Cod Tablets." The women here are working on salt fish, which they trimmed and packed in wooden boxes for retail sales in the Boston market. A fish glue container's label is shown at the bottom.

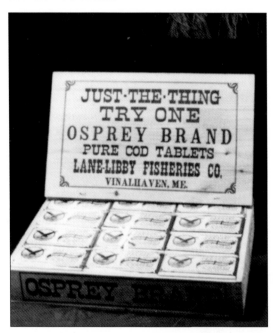

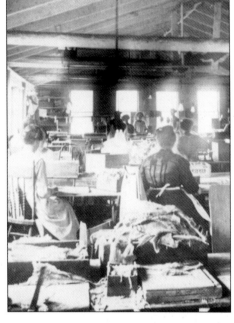

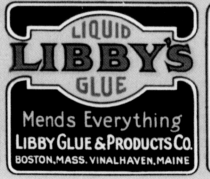

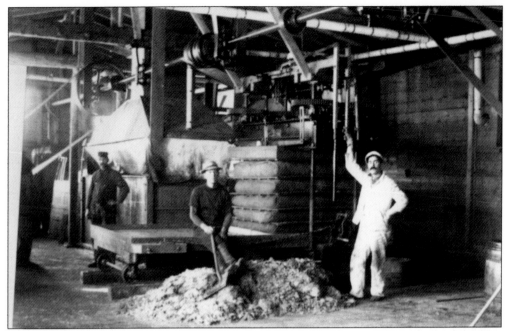

The top picture shows the press which forced oil from burlap bags of fish to make glue. The dry left-overs were packed for fertilizer. The bottom picture shows dried salt-fish being packed in barrels for shipment to wholesalers who sold it in the United States, Cuba, South America, and Europe.

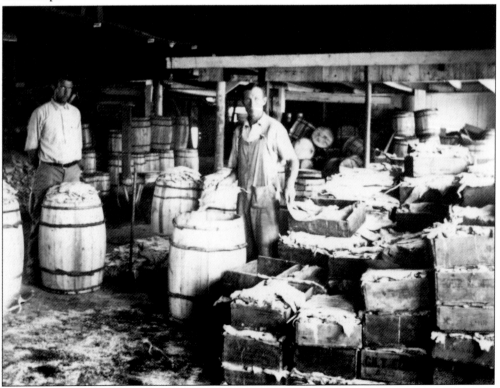

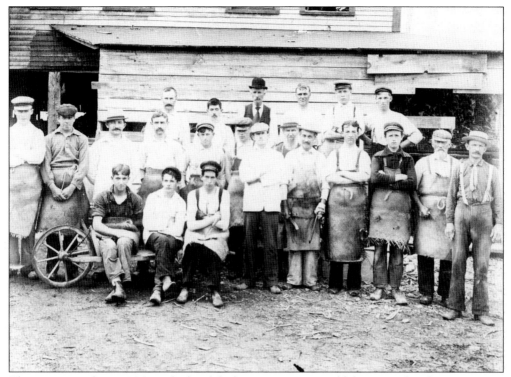

These men, in about 1885, worked as fish skinners, cutters, and laborers at the plant.

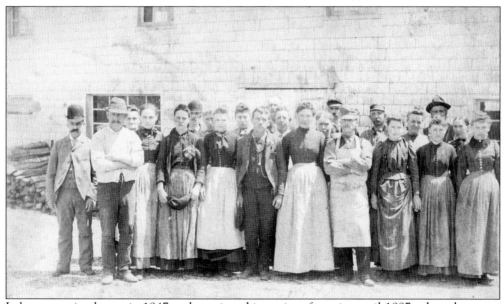

Lobster canning began in 1847 and continued in various factories until 1887, when they were closed by a federal conservation effort as the smallest lobsters were being used. This picture shows a group of canning factory workers in about 1884.

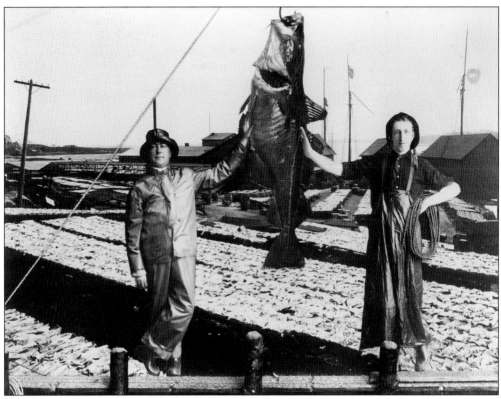

This staged 1910 promotional photograph shows Lane-Libby Fish Company president Thomas Edwin Libby on the left, in front of the company's fish-curing yard.

This picture by photographer Frank Winslow, also staged, shows Captain Emery Bray behind "a big one." For a number of years, the image was used as a colored Vinalhaven postcard.

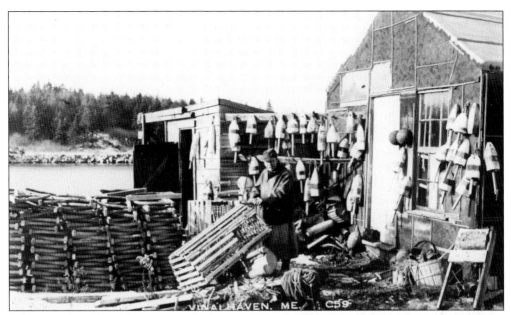

Lobstering has always been an integral part of the island's economy, but it became even more so after the close of the quarries and the decline in fin fish. The life of a lobsterman is hard, demanding work, but the opportunity to be one's own boss is vitally important to many islanders, and so Vinalhaven's offshore lobster fleet has become the largest in Maine.

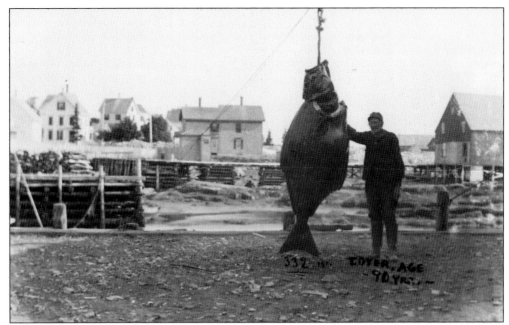

Ninety-year-old Timothy Dyer "astonished the people of Vinalhaven by bringing in a monster 332-pound halibut which he captured alone in an open dory," as reported in the *Rockland Courier-Gazette* in 1894.

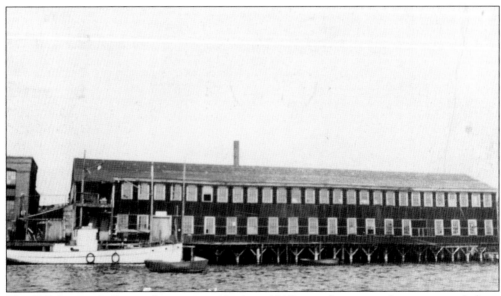

The H.F. Sawyer & Son sardine cannery, built in 1917 near the power plant, was razed about ten years later. On part of the site a new cannery was erected, which eventually became part of the Burnham-Morrill Co. and was managed by Hollis Burgess.

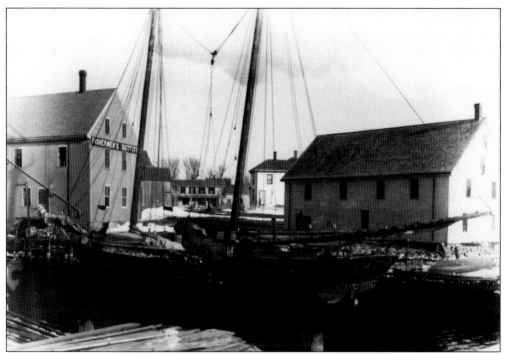

The early schooner *Polly* is shown here, around 1900, near Boman's sail loft. She worked as a "coaster" carrying lumber, stone, hay, and other freight for about one hundred years.

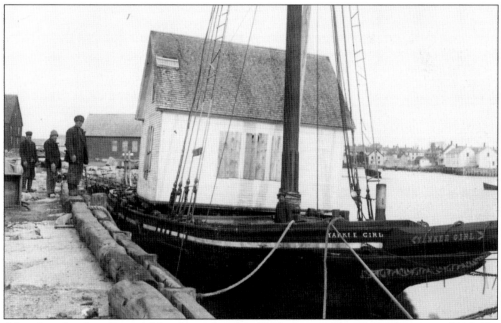

After the school on Green's Island was closed in 1907, it was sold to C.E. Williams in 1916. His son Leigh and other helpers brought it to Carver's Harbor aboard the old stone sloop *Yankee Girl*. As they prepared to unload, Hibert Smith came along, bought the building, and had them place it on the shore of Sands Cove, where it remains today.

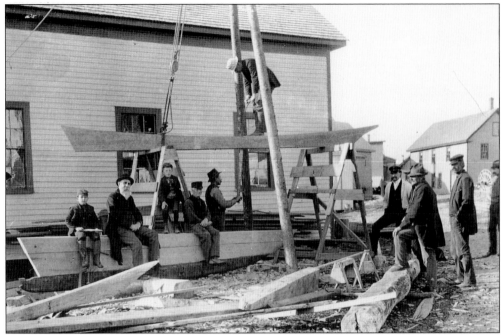

Laroy Coombs (1865–1950) was a talented and versatile man; in addition to being a master boat builder, he was a boat model-maker, an artist with oil paint, and a photographer. In the 1880s, he opened his first boat shop in Vinalhaven. He is seen here using a whipsaw to prepare a plank for the hull below. His boats went to other countries, his tenders went to the U.S. government, and some of his yachts went to Bar Harbor. He also built a vessel for Admiral Perry's daughter to take her to the Arctic.

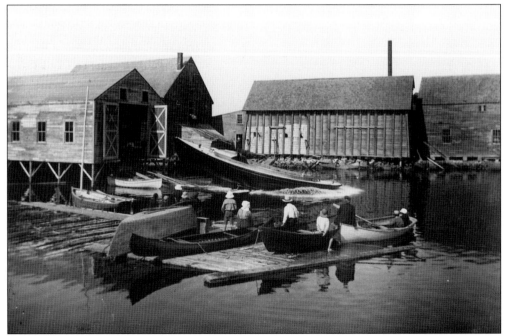

It is launching day at a boatyard at Harbor Wharf on Carver's Harbor.

The workshop of a late 1890s dory builder is pictured here.

Here in about 1906, Claes Boman, sailmaker, is measuring what will be needed for new sails at Abner Cooper's boat shop, which later became Carroll Gregory's shop.

Gosta "Gus" Skoog (1896–1987) came to Vinalhaven from Sweden in 1921 to cut granite but later built over one hundred boats, both for fishing and pleasure. Below is one of the small-craft models made by Gus that are on exhibit at the Penobscot Marine Museum in Searsport, Maine.

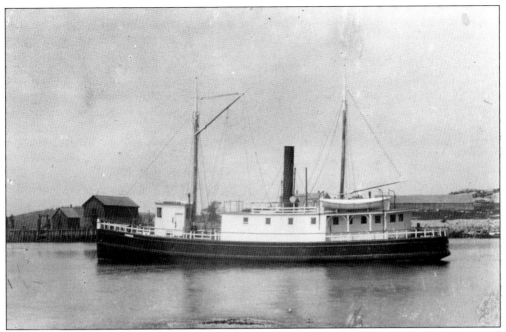

The Pioneer was the first steamboat to serve the island and ran from 1867 to 1892. She was owned by a stock company, skippered by Captain William R. Creed, and carried a set of steadying sails for rough weather or a disabled engine.

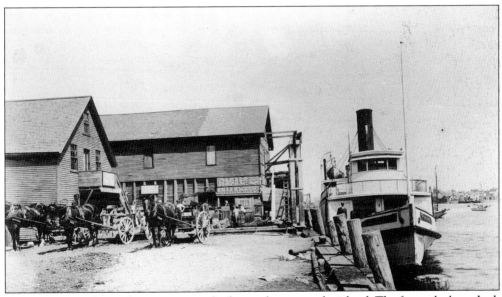

In 1892, two rival steamboat companies built vessels to serve the island. The first to be launched, on May 27, 1892, was the *Governor Bodwell*, shown here at the steamboat wharf. She carried both passengers (50¢ round-trip) and freight. Teamsters here are waiting in their carts, called jiggers, for freight.

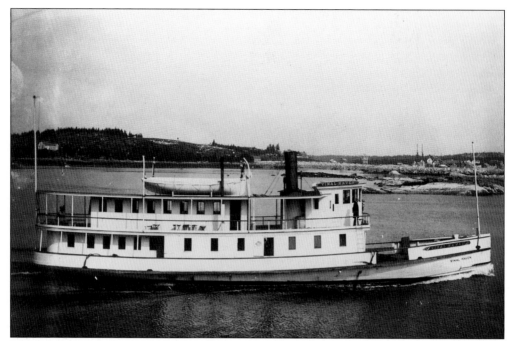

The second steam boat was the *Vinalhaven*. It entered service on June 2, 1892, with George Webster as captain. On January 13, 1893, she burned to the waterline, was rebuilt, and in 1905 was lengthened by 15 feet. Her service ended in 1938. The photograph shows her in her second phase.

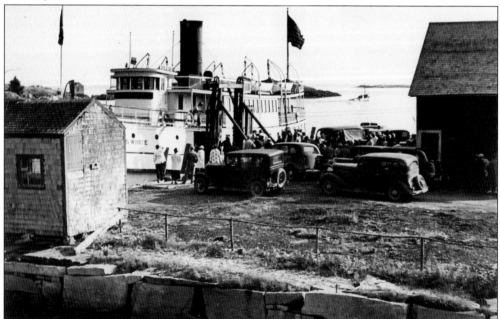

On May 13, 1935, the steamboat company placed the *W.S. White*, shown here at the town dock, in service. She ran two daily trips, except in winter when the route was covered by the *North Haven*. In February, 1942, during World War II, she and the *North Haven* were commandeered by the U.S. Maritime Commission.

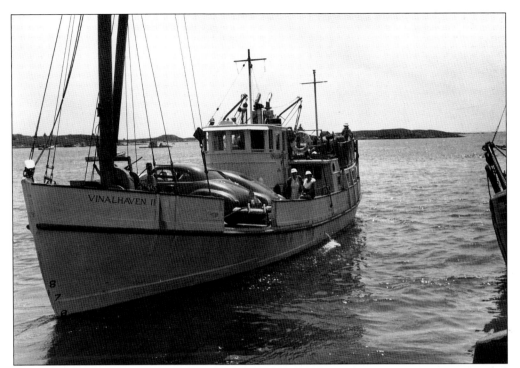

After the island lost the steamships, Captain Charles Philbrook ran his power boat, the *Ruth M*, as a passenger and freight boat for a year and a half. In August 1942, the town voted to raise $55,000 to build a "motorship" that could carry two autos. She was launched as the *Vinalhaven II* on June 17, 1943, and served until 1959.

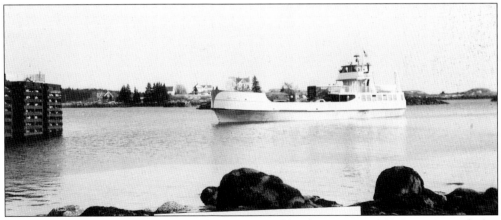

The M.V. *Everett Libby* began its Vinalhaven to Rockland service in 1960. It was named after Vinalhaven's A. Everett Libby, who was called the "father" of the Maine State Ferry Service for his efforts in getting its approval by the state legislature.

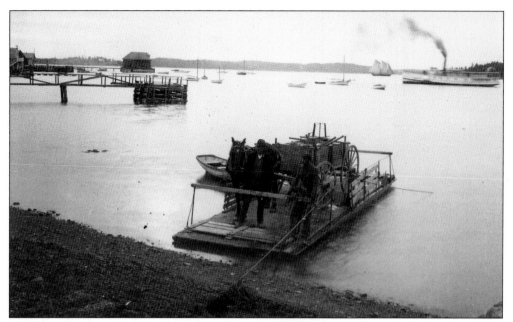

Another "ferry" existed for a number of years and carried people and vehicles across the Thorofare, to and from North Haven. This photograph, from about 1900, shows Captain Arthur Hopkins hand-pulling the barge to the shore on North Haven. In 1904, he bought a powerboat to do the pulling. The "waiting room" on the Vinalhaven side had a bell to ring to call for the ferry. The service was discontinued in the 1960s.

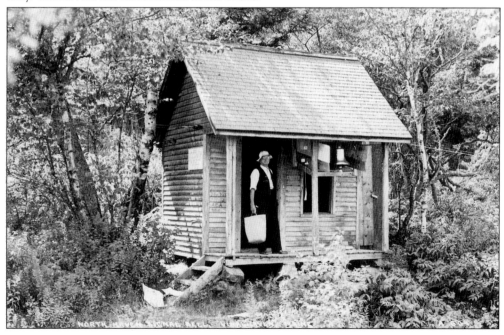

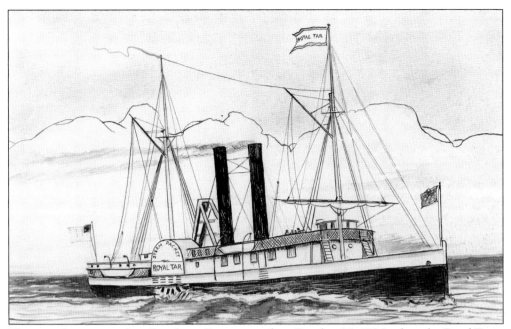

The most famous wreck in Penobscot Bay occurred on October 25, 1836, when the *Royal Tar*, a "sidewheeler steamship" with ninety-three people and "circus menagerie" aboard, caught fire in a gale off Vinalhaven's eastern shore. The vessel sank with a loss of thirty-two people and all the animals. This imaginative picture was drawn by Sidney Winslow in 1936.

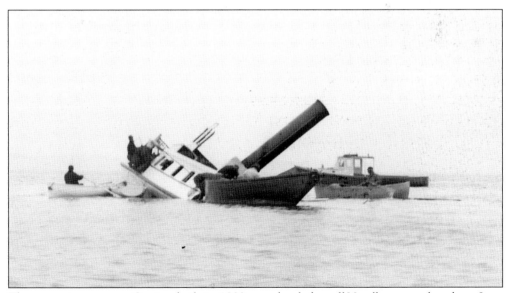

The excursion steamer *Castine*, built in 1889, struck a ledge off Vinalhaven and sank on June 8, 1935. She was carrying sixty-eight members of the Limerock Valley Pomona Grange, and all but four were rescued by the steamer *North Haven* and Vinalhaven fishing boats. The forward half of the hull still lies, bottom up, on Cedar Island.

In February of 1918, Penobscot Bay was frozen and no steamers could reach the island. Food for the livestock was gone and grocery shelves were almost bare. On February 4, the lighthouse tender, *Zizania*, arrived with a small amount of supplies, but for six more days, there were no boats. After appeals to the governor and Congress, a telegram was sent to President Wilson. The next day, February 10, the *Favorite*, an oceangoing tug, arrived with grain, supplies, and islanders who had been stranded on the mainland.

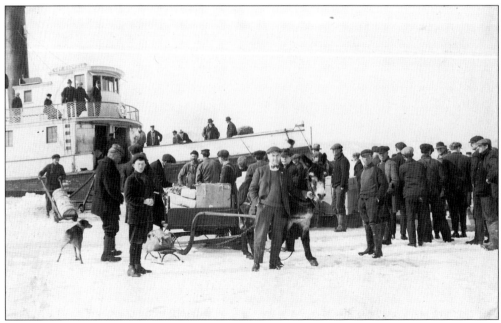

After the *Favorite* opened up the harbor, the *Governor Bodwell* was able to bring additional supplies and passengers to many island towns.

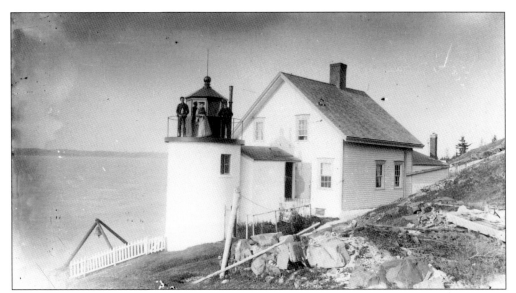

Ships in the vicinity of the island are protected by a number of lighthouses. This one, Brown's Head Light, stands on Vinalhaven's northwest shore. The lighthouse was first built in 1832 and was automated in 1987. Some of the keepers of the lighthouse were David Wooster, Howland Dyer, Benjamin E. Burgess, Charles T. Burgess, Alonzo Morong, Ernest Talbot, and Merrill Poor (U.S. Coast Guard 1945–55).

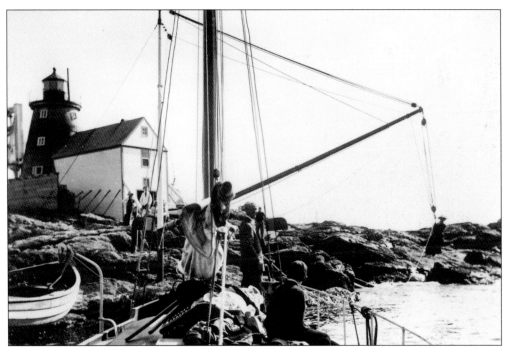

The Saddleback Ledge Lighthouse, built in 1839, was maintained by a keeper until it was automated in 1954. To go ashore on the ledge, it was necessary to be carried from your vessel in a bos'n's chair, swinging from a large boom, as the woman is doing in this photograph.

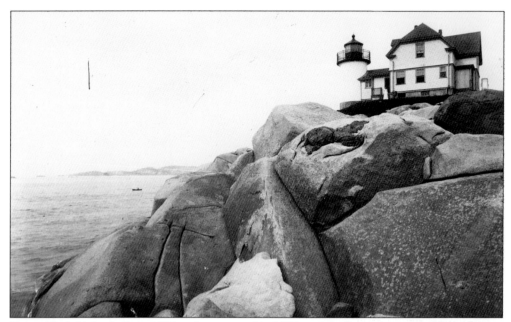

Heron Neck Light, built in 1854 and automated in 1982, stands above the rocks at the southern end of Green's Island.

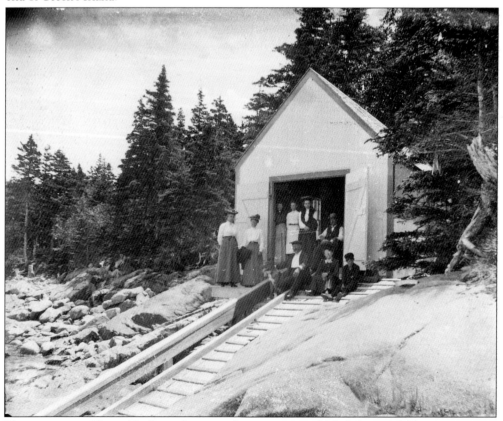

These visitors to Heron Neck are shown in the entrance to the lighthouse's lifeboat station.

Four

"Down Street"

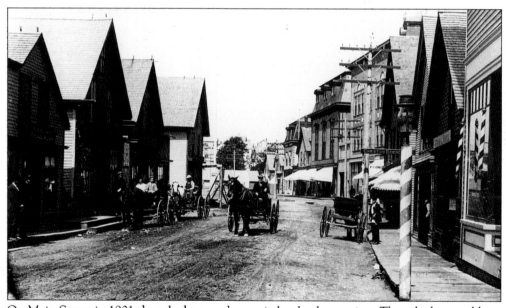

On Main Street in 1901 the telephone poles carried only phone wires. The telephone cable to Rockland was laid, and service begun on January 10, 1898. It was not until after 1914 that the poles also carried wires for electricity.

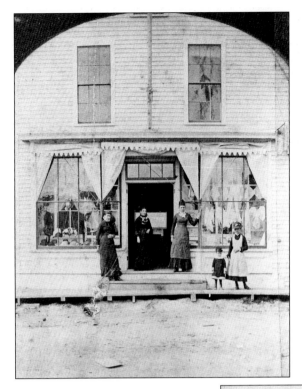

One of the early buildings on Main Street in the 1870s housed Hiram V. Lane's Millinery and Fancy Goods Store. Hiram was a ship's master and his store was managed for him by Jennie and Fannie Wasgatt, milliners, and Essie Mitchell, a dressmaker.

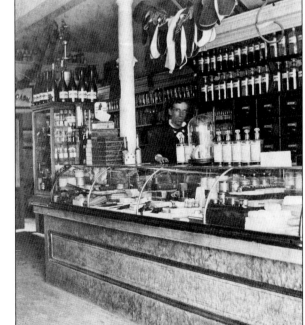

The three-story building on the northeastern end of Main Street had a drug store on the first floor for many years. In the mid-1870s, the first owner, Herman Lovejoy, had an apothecary and also sold boots and shoes in the back room.

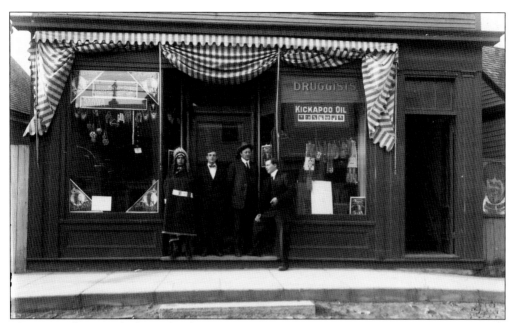

This 1909 photograph shows the drug store after it was purchased by Frank M. White, and the products of the "Kickapoo" Indians are being advertised. For several years, the "tribe" came to the island and put on "Kickapoo Indian Shows" at Memorial Hall to publicize their wares.

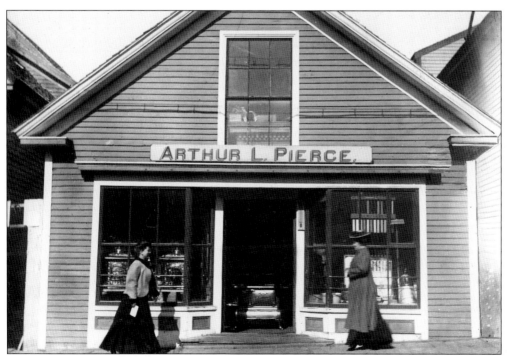

Arthur L. Pierce opened his stove and tinware shop on Main Street in 1895. By 1915, his business listing had changed to "pool hall."

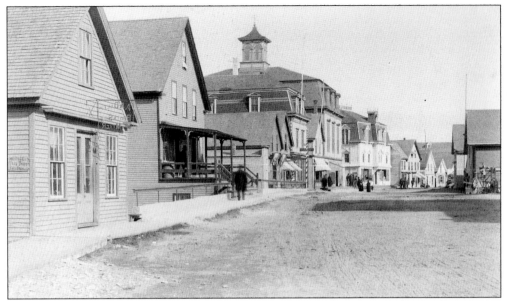

By 1887, Main Street had a substantial bridge across the Mill Stream, and several important buildings had been erected on the pond side. The second building in this picture, with the porch, was owned by James P. Armbrust and contained a boarding house and restaurant. It burned in the early hours of March 1, 1897, and was totally destroyed.

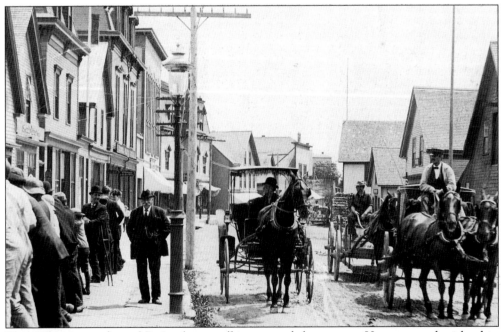

This 1904 picture shows J.P. Armbrust walking toward the camera. He came to the island in the 1870s from Pennsylvania as a "Railroad and Mechanical" photographer and "entrepreneur." He traveled as an agent for granite companies and also owned and operated the Armbrust Hill Quarry.

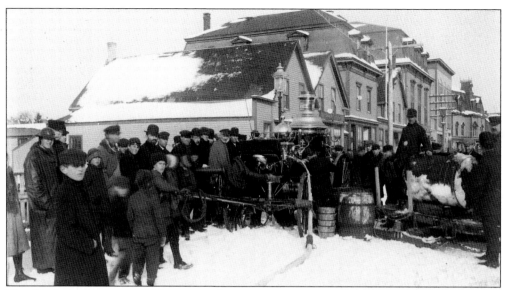

The Reuben Carver, a Silsby steam fire engine, came to the island in 1888, the year the Voluntary Fire Company was formed. It is shown on the Main Street Bridge on the morning after the Cascade House burned. The company was successful in protecting the buildings nearby.

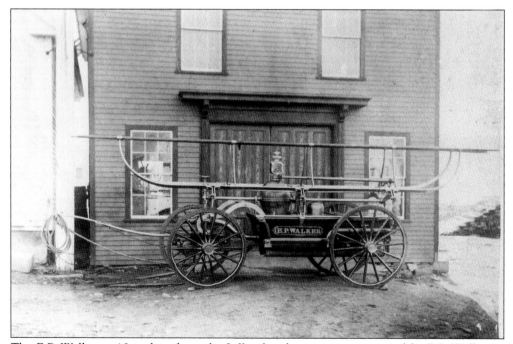

The E.P. Walker, a 10-inch, side-stroke Jeffers hand engine, was acquired by E.P. Walker in Brooklyn, New York, in April 1872. Mr. Walker received it in part payment for some of the granite for the Brooklyn Bridge. It was in service until 1876.

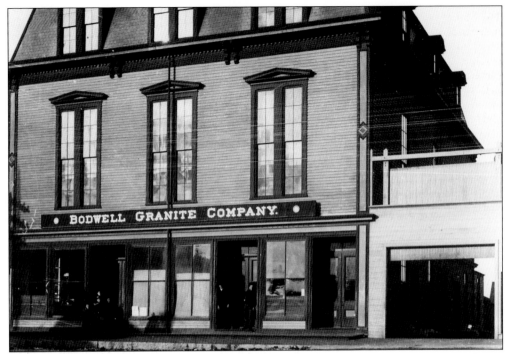

Central to the economic life of the granite workers and their families was the Company Store, which carried food, clothing, household goods, coal, wood, hay, and "plug" tobacco, which the store bought by the ton. Also of interest is the attached "storm door," which was dropped to keep the wind from howling across Main Street.

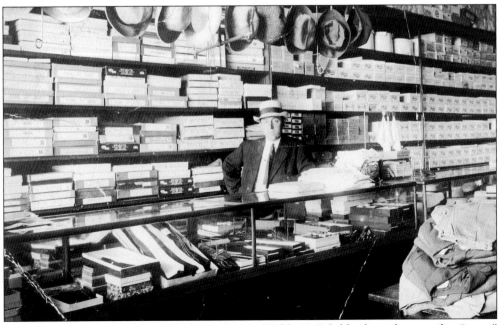

This interior view of the store shows Irving "Babbin" Fifield, the salesman for "gents" furnishings.

The Star of Hope Lodge of the Independent Order of Odd Fellows was founded in 1874. In 1885, it purchased two buildings, joined them together, and built a "fine hall" on the third floor. The first floor included H.Y. Carver's Fruit and Confectionery Store, later Carver's Spa.

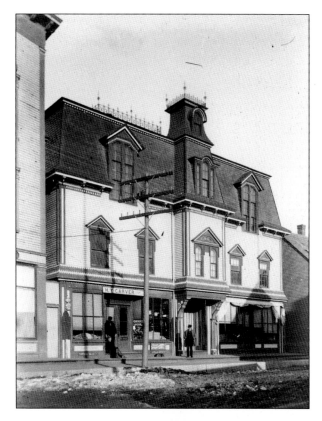

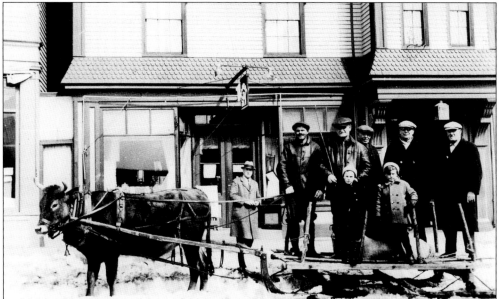

Seth Norwood drove his ox and sled "down street" and is seen here with others for a group picture in front of Carver's Spa. The "spa" was a very popular place for a number of years, especially with young people, because it had a soda fountain and served lobster stew after events at Memorial Hall.

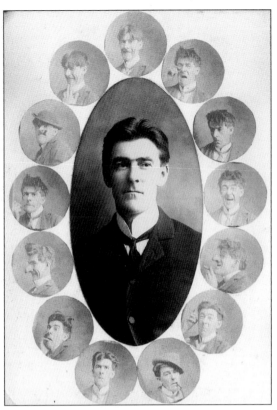

This is a self-portrait by photographer William H. Merrithew (1871–1940). Called "Bill the Facemaker" or Will, Merrithew documented the granite industry during the period 1890–1930, as well as photographing scenes of island life. His photographs appeared in the U.S. Geological Survey of 1907 and in Bodwell Company advertisements. One of Vinalhaven's most inventive minds, he made the island's first electric light; the first telephone, which was operated by his generator powered by a waterwheel at the Millstream; and a small printing press. In addition to all this he showed motion pictures and ran a successful portrait studio.

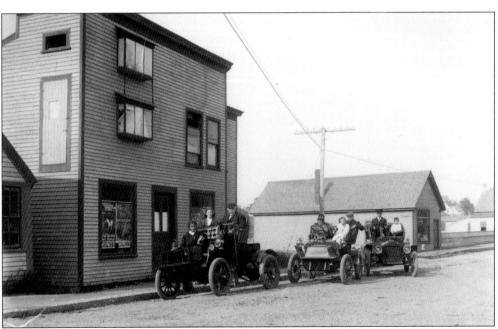

Parked in front of Will Merrithew's photographic studio are the island's first autos. From left to right are J.P. Armbrust in his 1903 Knox Model C, Will's 1903–04 Cadillac with Will's son Lou at the wheel, and Dr. Walter Lyford in his Model C Ford.

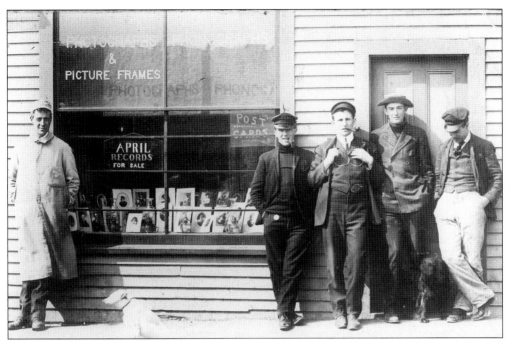

These young men are posing *c.* 1905 in front of Frank Winslow's Photography Studio and Phonograph Store. Frank, another of Vinalhaven's professional photographers, took over William V. Lane's Main Street studio in 1897.

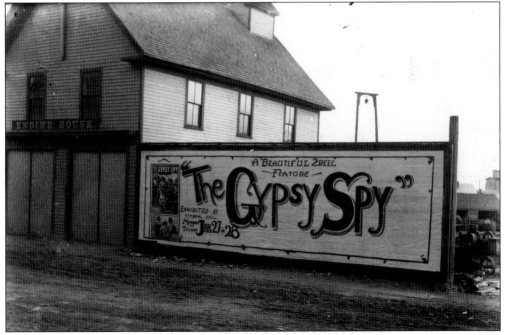

For many years, Sidney Winslow covered this billboard with paintings he made to advertise the coming attractions, motion pictures, and performances by traveling troupes at Memorial Hall, across the street. The board started at the "Engine House" and stretched in front of the Bodwell Granite Company's coal and woodyard, which later became Robertson's coal and woodyard.

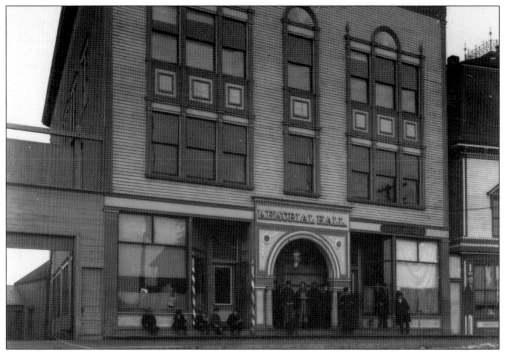

The GAR Memorial Hall was completed in 1895 at a cost of $10,000 and was dedicated on July 4. The first floor contained a store and the post office, with the GAR rooms in the back. The second floor had a stage and a large hall, seating six hundred, and also a balcony around three sides.

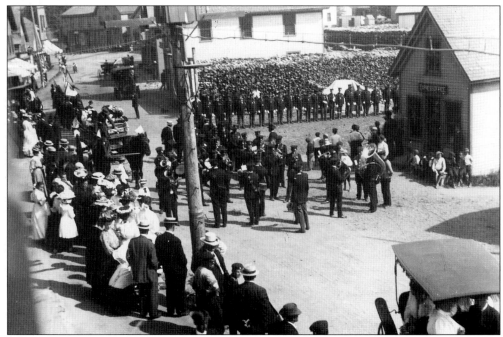

This group of men is shown lining up across from Memorial Hall and the Masonic Block in the early 1900s for a funeral march. The Bodwell Granite Company's wood yard can also be seen.

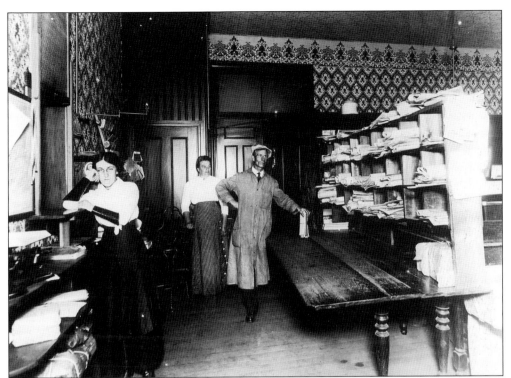

Fred E. Littlefield, postmaster from 1898 to 1915, is shown with clerk May Arey (Tolman) at the window of the post office in Memorial Hall.

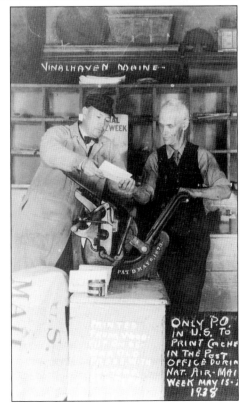

In 1938, the Vinalhaven Post Office printed its own cachet on John Gordon's antiquated printing press. Postmaster O.V. Drew is shown checking the envelope.

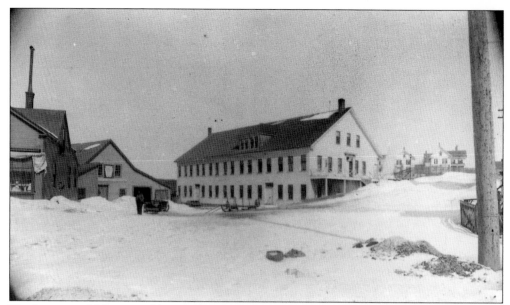

The knitting of fishnets and later of horsenets (to protect horses from bothersome flies) was an important part of the island's economic life from 1847 until 1926, although after that date nets of various kinds, including pool table pockets, continued to be made in smaller quantities. A large factory was constructed by the town in 1897–98 to attract the L.M. Chase Co. of Boston to the island. Eight steam-powered looms and other "modern" equipment were added, and the company shipped many thousands of horsenets, made in 140 designs, per year. The women shown below are preparing packages of "ear tips" sold to protect the ears of horses.

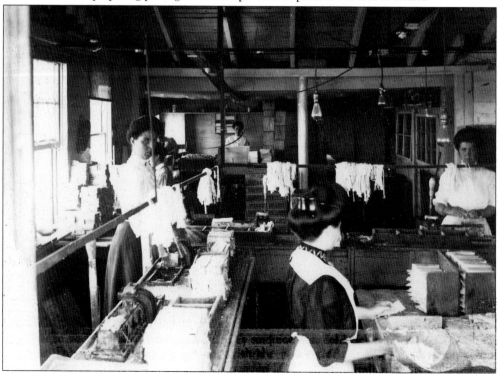

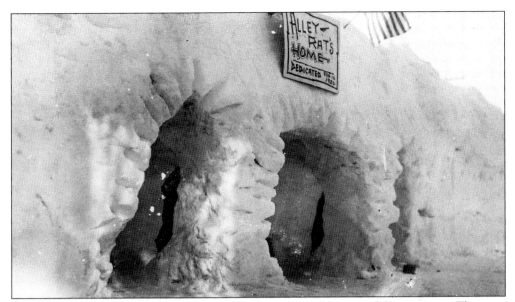

Several snow "buildings" were constructed in the center of town at different times. This one, called "The Alley Rats Home," was "dedicated February 16, 1926."

The night the schoolhouse burned down in 1894, the "lockup" did also. The story goes that "a guest of the town" in the jail set fire to both buildings. The jail was replaced by a granite one that is still standing behind Main Street but is only used for storage.

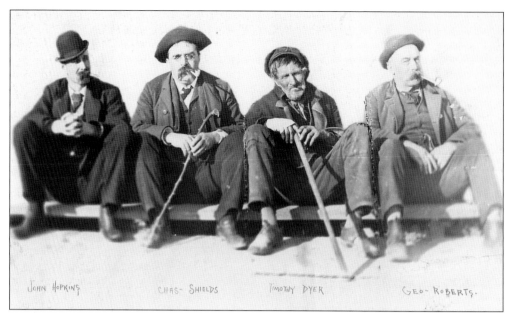

John Hopkins Chas. Shields Timothy Dyer Geo. Roberts

Four venerable citizens are shown here sitting on the edge of Main Street's wooden sidewalk in the 1890s. From left to right are John Hopkins (granite contractor), Charles Shields (grocer), Timothy Dyer (fisherman), and George Roberts (boarding house proprietor).

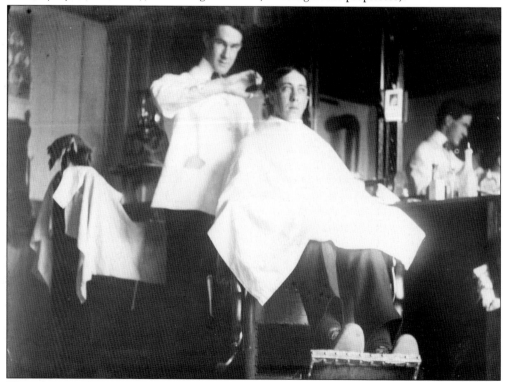

This photograph inside Joe "Kitt's" barbershop shows Joe Kittredge cutting Irving "Babbin" Fifield's hair. Barbershops were also places to catch up on news, just as "the Bench," the hardware store, and fish houses were.

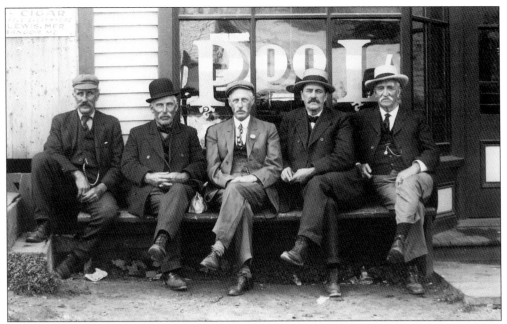

"The Bench" in front of the pool hall was certainly used for a lot of photographs. This *c.* 1910 picture shows, from left to right, Kent Roberts (stonecutter), Captain Elisha Roberts (of the coaster *Harvester*), Frank Gould, Will James (Livery Stable proprietor), and Charles Roberts (attorney).

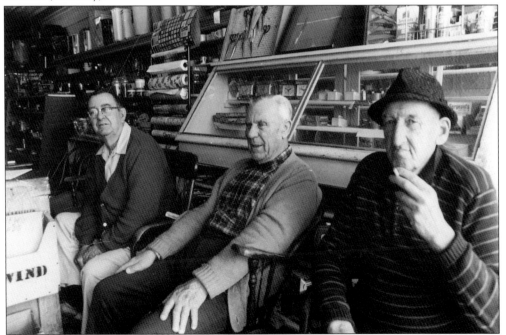

In 1946, when cousins Bruce Grindle and Clinton "Kim" Smith took over Fifield's Hardware, "the Bench" was replaced by a row of chairs in the store. This 1985 photograph shows three local historians. From left to right are Kim Smith (town clerk for twenty-four years), Bruce Grindle, and Paul Christie (who had retired from sailing on large fishing vessels).

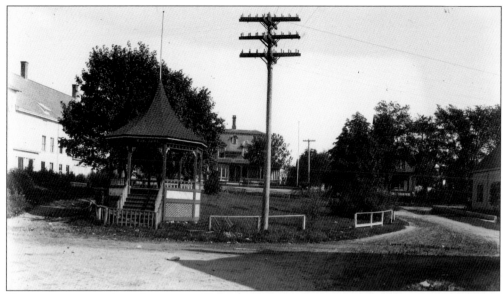

These two pictures show the corner of Main and Water Streets, about sixteen years apart. The 1895 photograph above shows the bandstand, built by the W-14 Club, at the edge of the lawn in front of the Moses Webster/Frederick Walls house. To the left stands the "Carver Block," a row of six units built by Reuben Carver in 1857 for his daughters. By the time this 1911 picture was taken, the bandstand has been moved up the hill across from the town library. Also, Frederick and Lucie Walls have erected the watering trough, which was made by the Bodwell Granite Company and mounted with a gas light, in honor of Lucie's father, Moses.

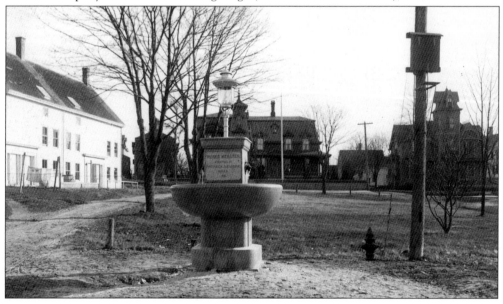

Five

Commemorations
and Celebrations

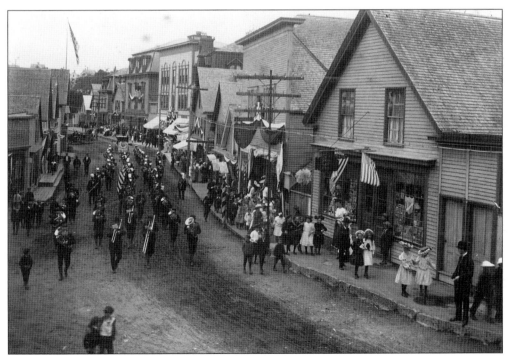

Every St. John's Day, on June 24, the Commandery would march from the Masonic Lodge to the Union Church. The DeValois Commandery No. 16, formed in 1886, would often be joined by a visiting commandery from the mainland.

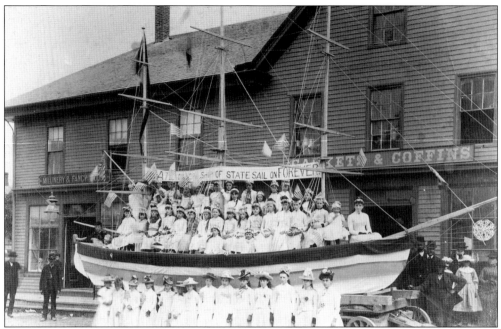

For weeks, the people of Vinalhaven worked on preparations for the town's 100th birthday celebration on June 25, 1889. A very large group of people turned out to see the festivities. One of the outstanding floats in the parade was a full-rigged ship with the motto "Sail On O Ship of State, Sail on Forever." The ship carried forty-two girls in white dresses, ranging from ten to seventeen years old, and it was pulled in the parade by ten yoke of oxen.

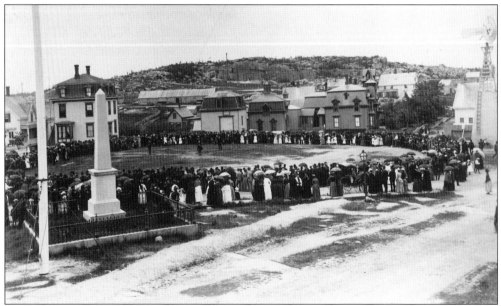

In the afternoon, a baseball game between a Vinalhaven team and one from the Rockland Commercial College was held. Although Rockland won 25 to 7, the crowd was enthusiastic. The picture also gives a good view of the Armbrust Hill Quarry, which is in the background. The centennial celebration pictures were taken by photographer William V. Lane.

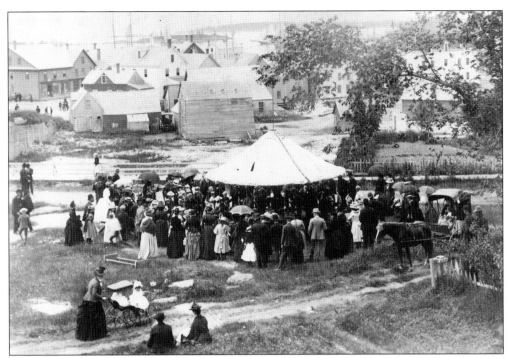

Sidney Winslow wrote, "One feature which was . . . a source of great interest and excitement among the children was the Merry-Go-Round, which had been installed near the spot where our public library now stands." A man in the center turned a crank "to make the contraption revolve," and music was supplied by a fiddler.

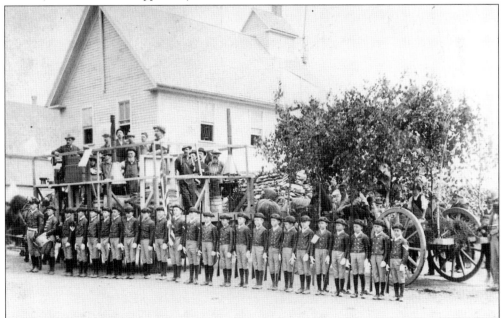

Twenty-five young boys, dressed as the Boy Continentals, marched in the parade. Behind their line are two of the floats representing the granite industry; the first float carries tool sharpeners with a forge, and the second is a float representing the work of quarrymen.

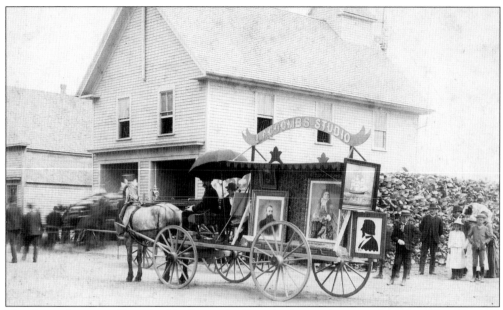

The float of artist and boat builder Laroy A. Coombs depicted an artist's studio. The float had Mr. Coombs in front, working on a portrait of General Winfield S. Hancock, which he later presented to the island's Lafayette Carver GAR Post.

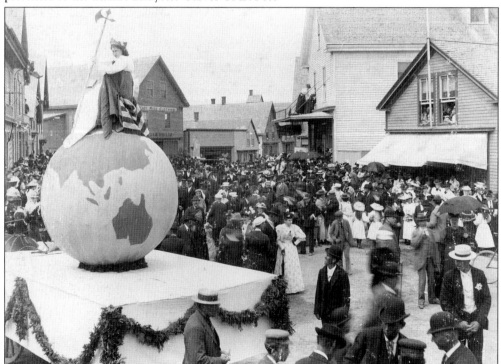

During the 1880s and 1890s, Vinalhaven was experiencing its greatest peak of population and prosperity. In 1895, another elaborate celebration took place on Independence Day, held on Monday, July 5. Again, the floats were exceptional and the crowd was large and enthusiastic. Laura Sanborn portrayed Miss Liberty atop a globe.

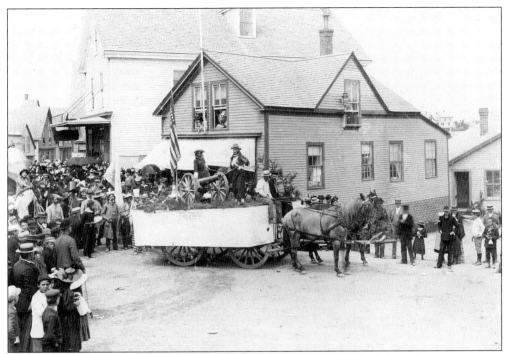

Also in 1895, this float portrayed "Moll Pitcher and the Battle of Monmouth." Eugene Hall was "Moll," and at the left, Frank Winslow played Moll's husband. Will Merrithew can be seen riding the bicycle in front of the "elephant."

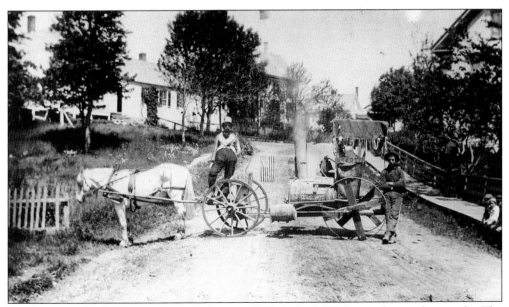

This homemade "locomotive," with the sign "US & D.T. RR," was also in the parade. The reference was to the fact that the Bodwell Granite Company was considering the construction of a railroad from the quarry at "Dog Town" to the Stoneyard.

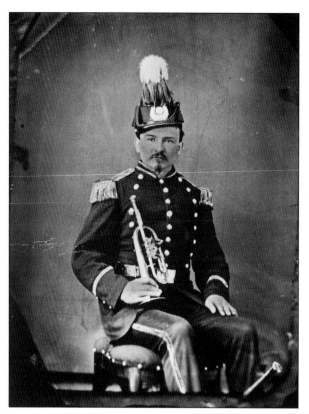

O.P. Lyons (1850–1933), the "father of all Vinalhaven bands," was born in Nova Scotia of Irish parents and came to Vinalhaven in 1865. A stonecutter and later a jeweler, he was the director of the first band in 1870. He then founded the first newspaper, *The Wind* in 1884, wrote the centennial *Brief Historical Sketch of the Town Vinalhaven* in 1889, was town clerk for thirty-eight years, and served as fire chief, postmaster, and state senator. The picture is a copy from an original ferrotype. The 1884 Band, with O.P. and his cornet, is shown below.

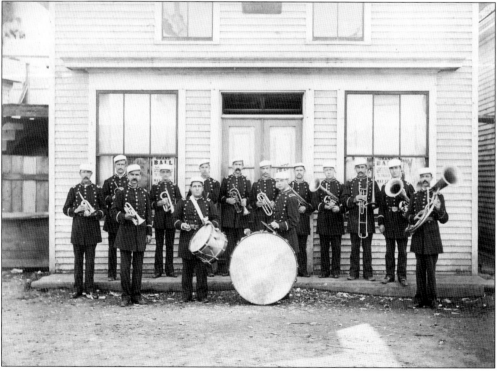

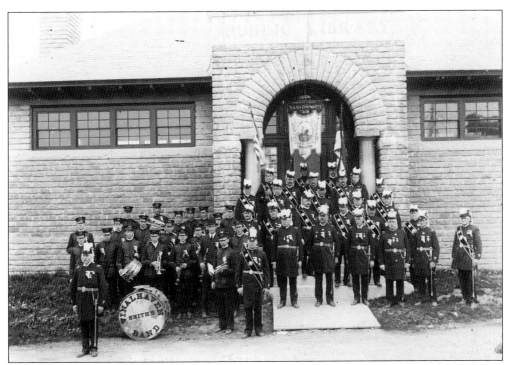

The DeValois Commandery, with Smith's Vinalhaven Band, are seen posing here on the steps of the public library, prior to their "pilgrimage" to Castine on June 24, 1907.

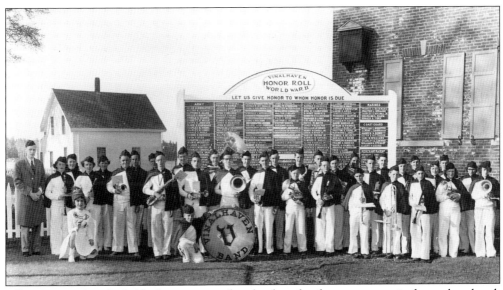

Allen Simons (on the left), the music teacher for the school system, organized a student band. It made its debut on Memorial Day, 1952, and posed for this picture in front of the town's World War II Honor Roll.

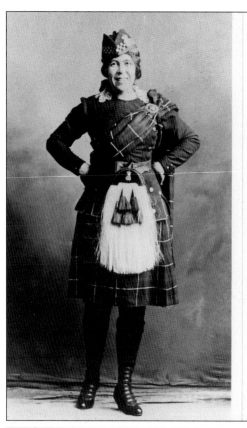

Burns Anniversary ➤
Concert and Ball ➤

MEMORIAL HALL, VINALHAVEN,
Friday Evening, January 25, 1901.
Music by the Vinalhaven Orchestra.

Music has always been an important part of island life. Several islanders went on to distinguished careers in music. Albra Vinal Smith, a graduate of the New England Conservatory, returned home to perform vocally and on the piano at such events as the Robert Burns Concert and Ball. This annual event, organized by the Island Scots, took place for a number of years. Many wore full Scottish regalia, and the Scotch Reel and Highland Fling were danced.

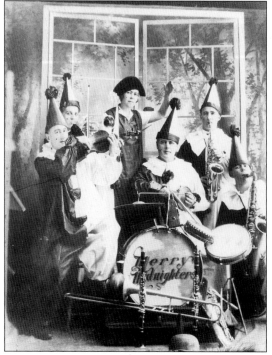

One of the musical groups which played for parties and dances, and for their own enjoyment, was Albra Smith's Merry Midnighters. Besides Albra, the group included Veli Holmstrom, Owen Roberts, Langtry Smith, Walter "Shag" Ingerson, and Albra's son Kilton Smith.

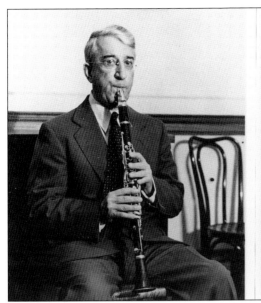

R. Mont Arey (on the left) was a nationally known clarinetist. In 1927, after playing with the Detroit Symphony, he joined the Rochester Philharmonic, where he led the clarinet section until his retirement in 1954. Leonard Hokanson (right) was known for his accordion playing as a boy; by 1959, he was an internationally known concert pianist. He now teaches at Indiana University and is an active recording artist.

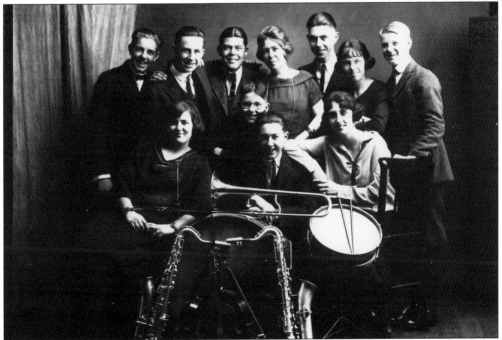

One of Albra Smith's jobs, as the school's teacher of music from 1915 to 1928, was to direct the school orchestra. Her son, Kilton Vinal Smith (standing third from the left), played the saxophone at the time and went on to the New England Conservatory and a long, successful career as the tuba player for the Boston Symphony Orchestra.

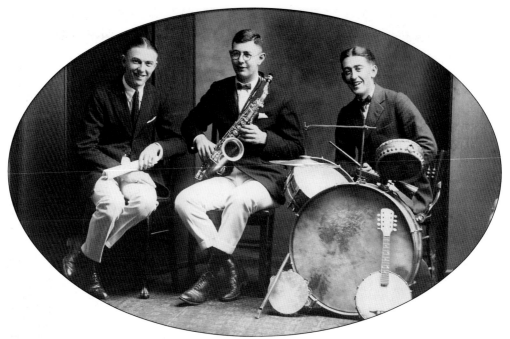

Another group that played for parties and dances was Lou's Melody Jazz Trio. From left to right are Arthur Brown, Leon "Goose" Arey, and Lou Merrithew.

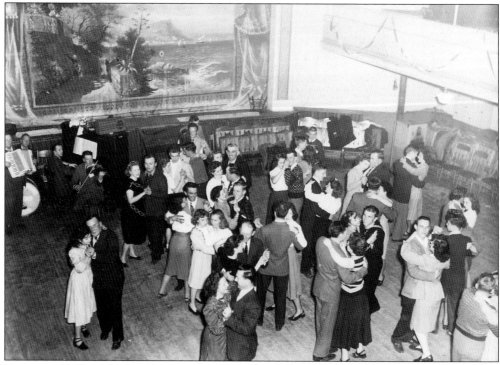

Dances and balls took place frequently at Memorial Hall. The music on this evening in the early 1950s was provided by Arthur Brown (piano), Fred Swanson (fiddle), Jack Carlson (accordion), and Kippy Greenlaw.

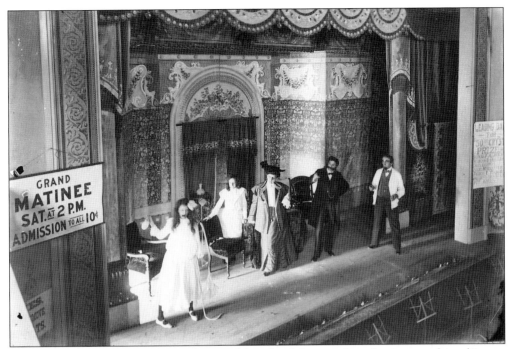

The stage in Memorial Hall was often used for island theatrical productions, such as this one in 1903.

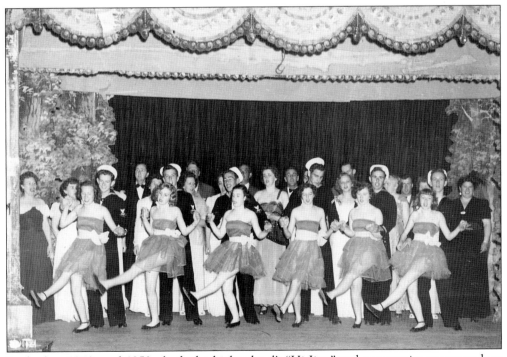

In the late 1940s and 1950s, both the high school's "Hi Jinx" and community groups such as the Island Players put on musical productions. This one, a musical review with songs from *South Pacific* and other Broadway shows, took place in the early 1950s.

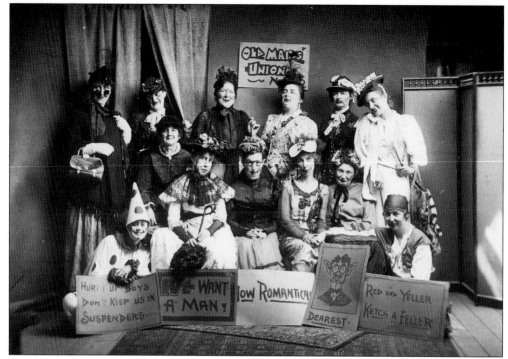

Vinalhaven has always had a wide variety of clubs: cultural, musical, card, craft, theatrical, or for just plain fun. These ladies of the Old Maids' Union, in about 1908, have certainly gone through a lot of work to prepare this tableau and to call in Will Merrithew to take their picture.

Because a number of these men appear to be quarrymen, it is assumed that this First of May celebration took place on a Sunday. It is obvious from the picture that this is not a group practicing temperance.

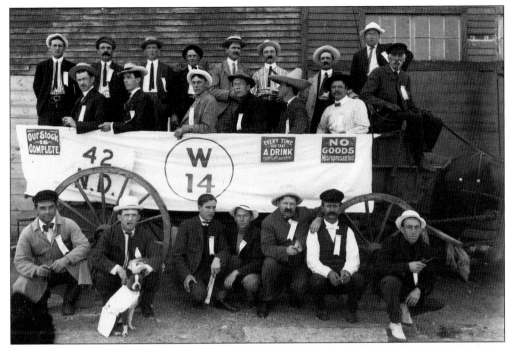

On February 14, 1892, a group of men formed a secret society called the W-14 Club. The group built the bandstand and donated it to the town in 1895. Although the names of the members are known, their purpose and the meaning of their name is unknown. Because the Women's Christian Temperance Union (WCTU) and the Temperance League were also formed in this period, and because of the motto on their parade float in this picture, the authors wonder if temperance, pro or con, had anything to do with them.

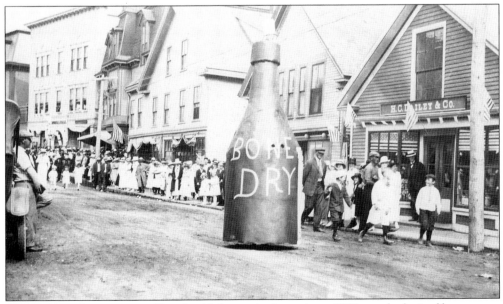

This picture of an entry in a Fourth of July parade, from about 1915, speaks for itself.

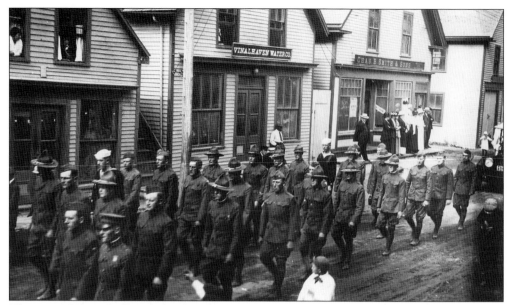

The town's Honor Roll includes the names of sixty-eight islanders who served in World War I, some of whom are marching in this parade.

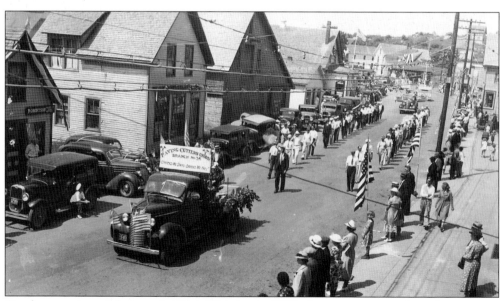

On the occasion of the town's 150th birthday in 1939, the town organized another massive celebration. Vinalhaven family members from around the country came home for the festivities. One of the participating groups was the Paving Cutters Union. A truck driven by Nils Stordahl led the union members. A few months after this picture was taken, the island's granite quarries were silent, and some of the men dispersed to find employment elsewhere.

Six

Churches, Schools, and Island Services

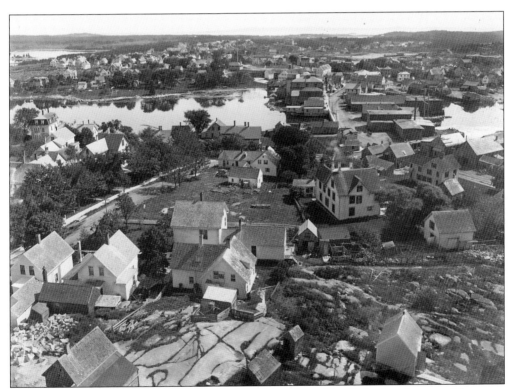

This overview of Vinalhaven was taken by Will Merrithew. He climbed to the top of the water tower (constructed in 1910) with his large camera and glass plates to take this wonderful view. The image shows Main Street at the height of its development.

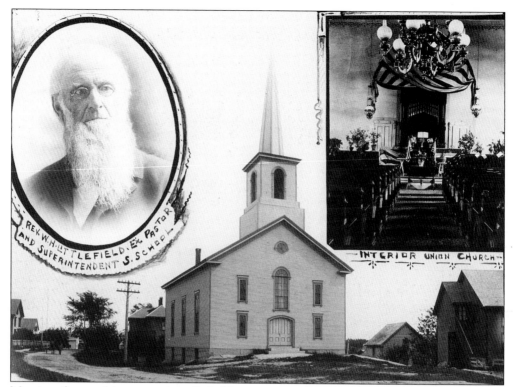

INTERIOR UNION CHURCH

Meetings for worship were originally held in various school buildings and private homes. In the early part of 1860, a group of citizens formed a society for the building of a church, with building committee members Reuben Carver, Timothy Lane, and Moses Webster. The first Union Church was dedicated on October 10, 1860. During the night of March 23, 1899, the church was destroyed by fire.

The foundation for the new Union Church was started July 27, 1899, the cornerstone laid September 27, 1899, and the church was dedicated on June 27, 1900. The architect was John Calvin Stevens, who was nationally known for his contribution to the development of the Shingle style.

The oil painting above the choir in the Union Church, entitled *Master, Is It I?*, was painted and donated by Laroy Coombs. It was dedicated in 1936 at a special Sunday service.

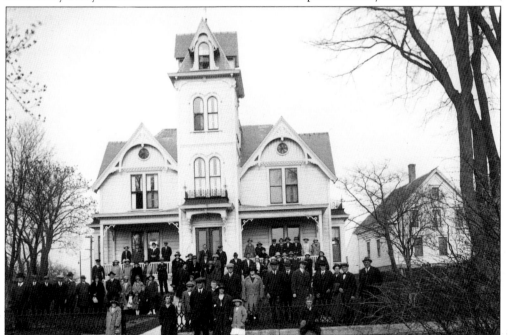

In 1916, the Reorganized Church of Jesus Christ of Latter Day Saints was established in Vinalhaven, and in 1920, the church purchased the former home of Bodwell Granite Company officer Edward P. Walker, on Atlantic Avenue. In 1988, the church building was sold and a new chapel was built at Vinal's Meadows.

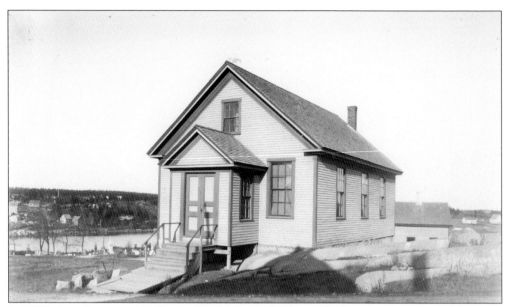

In 1887, the religious society known as the Second Advents built a chapel on the hill between the "Town Hall" and the District Four schoolhouse. In the early 1900s, the congregation was small but very active under the leadership of Reverand William Strout and his wife. The interior picture below shows the chapel decorated for the Memorial Day service in 1904.

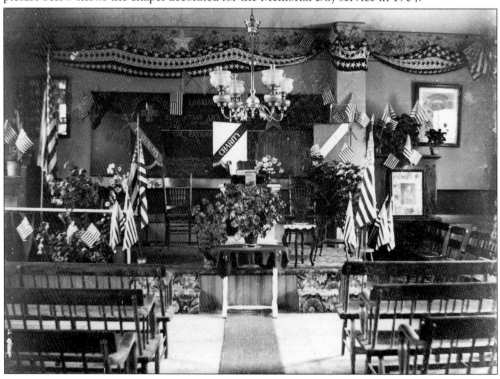

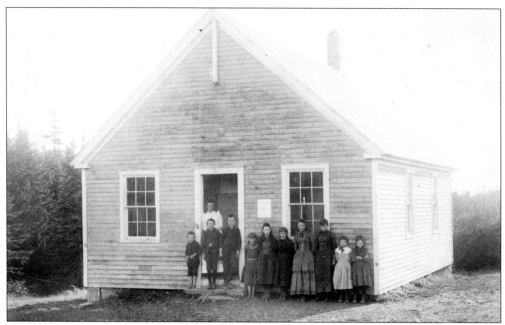

Jeannette Shields was the teacher in the Crockett's River School, District Six, in 1897. The students were members of the Wooster, Young, Thayer, Hopkins, and Crockett families. It was located at the junction of Crockett's River Road and North Haven Road.

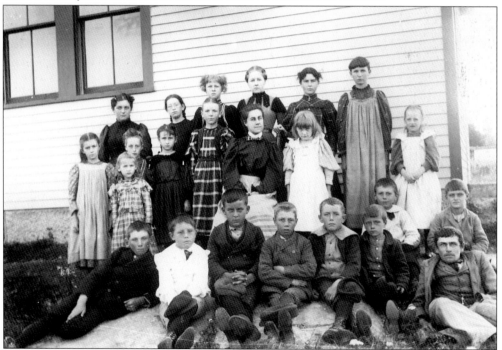

At one time, when Hurricane Island was part of Vinalhaven, there were thirteen school districts. By 1902, the number was nine. Outlying districts had one-room schoolhouses, and the teachers boarded at nearby homes. In 1896, Arey's Harbor, District Two, built a new schoolhouse, where these students and their teacher, Carrie Crockett, were photographed.

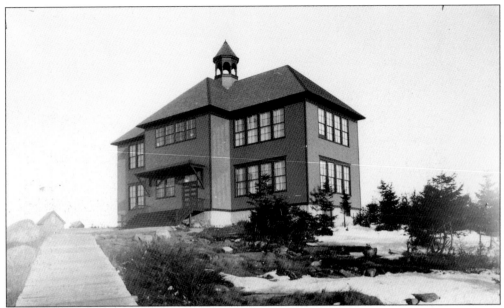

In 1894, a fire of incendiary origin, started by the man who first burned the "lockup," destroyed the school building in District Three. A new school, called the Lincoln School, was built on the site. The students below were photographed on the front steps of the new school.

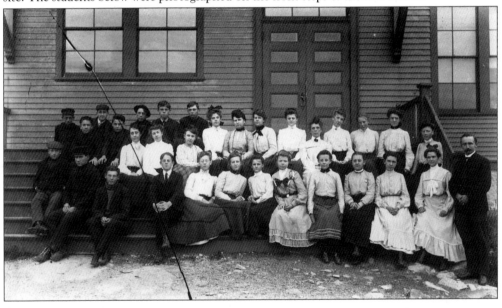

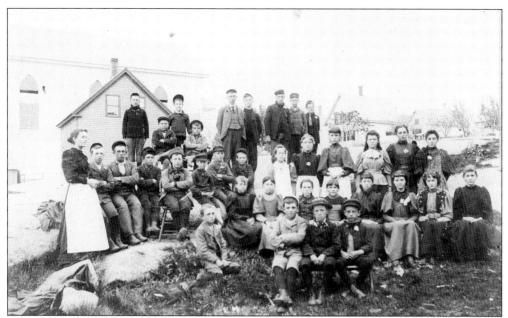

By 1895, when the picture above was taken, the District Four schoolhouse on the hill near the town hall had become too small to house all the children. In 1896, a new building was erected and named the Washington School (below). It housed elementary grades until 1973, when all classes were combined in the Lincoln School.

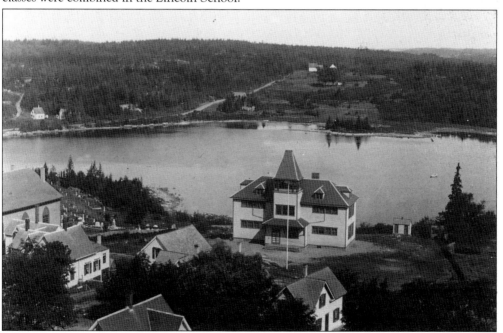

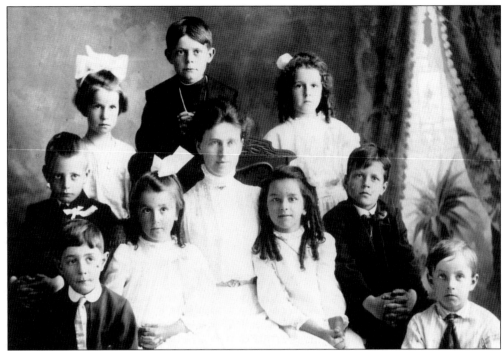

The White School at the corner of School Street and East Boston Road, as shown in the photograph on p. 104, was used by the lower grades during the late 1800s and into the 1900s. The students in this picture from about 1912 are, from left to right: (front row) Leon Arey and Alfred Hall; (middle row) Crockett Hall, Leola Bradstreet (Smith), Lucy Reynolds (teacher), Marjorie Wright, and Hiram Pulk; (back row) Virginia Black, Ronald Aldrich, and Ruth Smith.

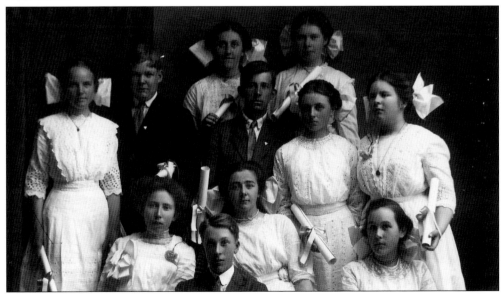

These students are graduating from ninth grade in 1910. Ninth-grade graduations were held for a number of years. Completing twelve years of school was not common for all boys, as some of them went to work in the quarries as young as age thirteen (see p. 26).

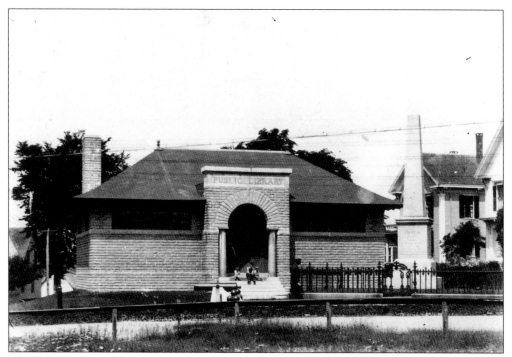

The Vinalhaven Public Library was constructed in 1906 and was financed by a grant of $5,200 from Andrew Carnegie. It is one of the few island structures built of granite, both Vinalhaven grey and red granite from the Bodwell Quarry at Jonesboro.

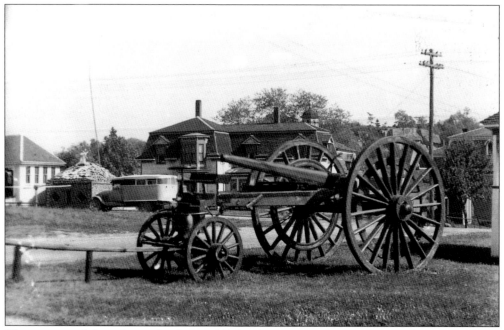

This picture of the galamander (see p. 21) by the bandstand was taken in the 1930s. In the background is the school bus driven by Ray Webster, and next to it stands an interesting looking building which was actually Robert Arey's wood pile.

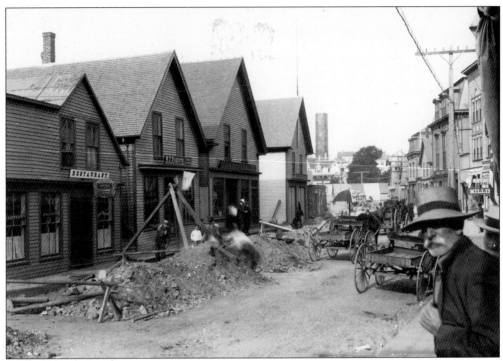

In 1910, a standpipe was erected on Harbor Hill, and water mains were laid along Main Street and in other parts of town. Granite had to be blasted out in a number of places before the pipes could by laid.

This photograph, from about 1919, shows the power plant that generated electricity for the Light and Power Company, which began in 1914. Coal was originally used but was soon replaced by diesel fuel. Also seen are two businesses conducted from barges.

Ralph P. Earle, M.D., served as the island's doctor from 1937 to 1975, with the exception of time missed during his military service in World War II. Dr. Earle delivered many island children and helped establish the Islands Community Medical Services, Inc. in 1945, as well as the ICM Center, which opened in 1962. Dr. Earle was nationally known for his study of diabetes on the island.

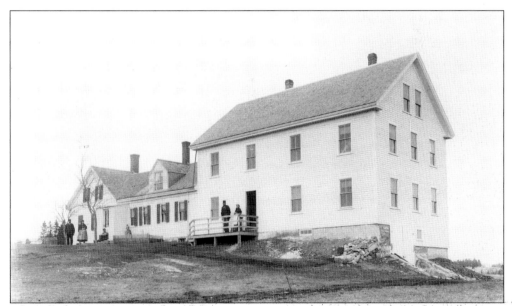

Care for the indigent citizens of the island was always a part of the town's budget and originally was "put out to bid." In 1895, the annual town meeting voted to pay Frederick Walls $900 for a farm of 100 acres. The newly purchased land was to be run as the Town Farm at Smith's Cove. The three-story extension was added to the house, and the farm was used until the 1940s.

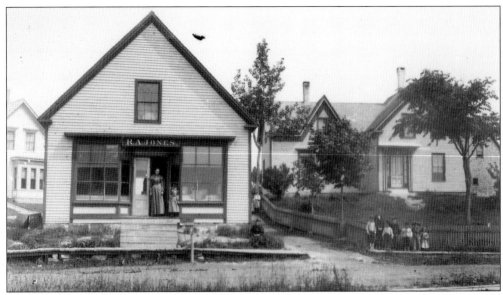

Outside of town there were small neighborhood, owner-operated stores, which today would be called convenience stores. This store, which was started in 1889, was owned by Roswell A. Jones. It stands at Jones' Corner, East Main Street and Beaver Dam Road, where later Mont and Frances Oakes ran a grocery store.

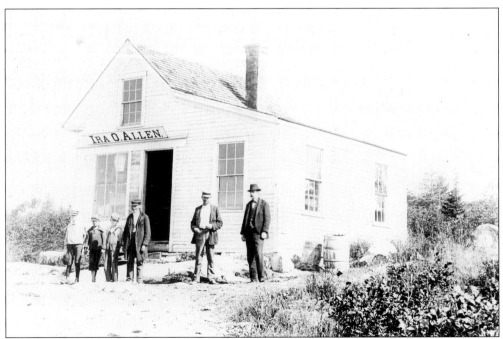

Ira O. Allen's store, along the road at Old Harbor, was listed in the Maine State Register from 1889 until about 1920. In this picture, Ira stands at the right.

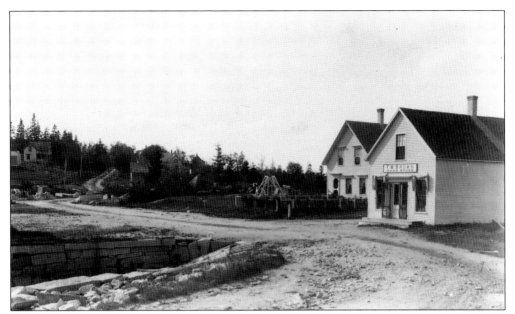

This "cash" store owned by Frank M. Brown was started by 1888 at the head of Sands Cove, on the road to Old Harbor (today the road runs behind the building). By 1920, Frank had turned the store over to his daughter-in-law, Lettie B. Nelson.

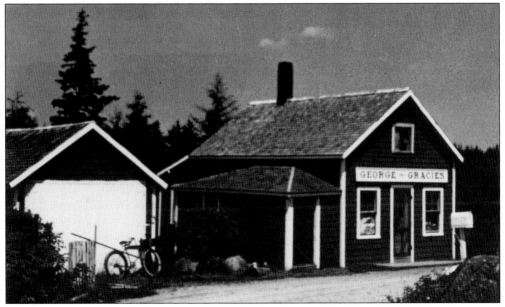

This small store on Old Harbor Road, built by Henry Newbert, dates back to the 1920s. It was owned by George and Gracie Lawry from the late 1930s until the 1950s, when the Lawrys passed away. It was then taken over by Edith and Maurice Norton. The bicycle in the picture belonged to George who used it for deliveries because he did not drive.

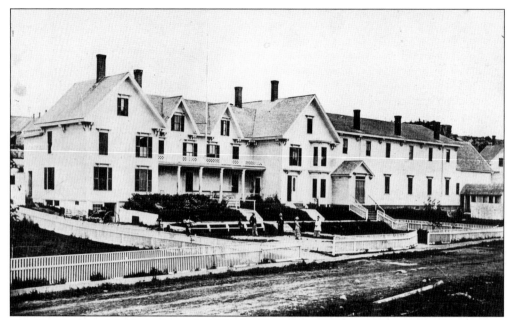

The Granite Hotel, built in the early 1870s by George Roberts, was a famed island attraction. In 1877, owner R.T. Carver added a large hall on the south side, as shown in the picture. The hall was used for balls, musical events, traveling shows, speeches by famous orators, and union meetings. The town's loss was great when the building burned down on March 30, 1886.

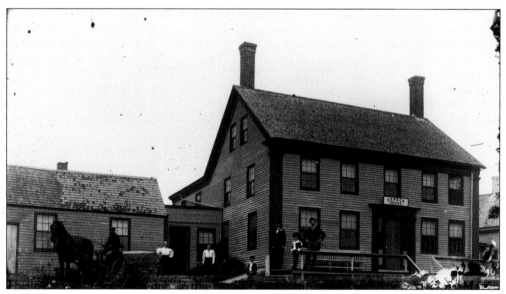

Harbor House, on Main Street beyond the Central Hotel, was a busy boarding house until it burned in 1903. The wagon in the yard is there with Seth Smith's Seal Bay Milk Farm delivery.

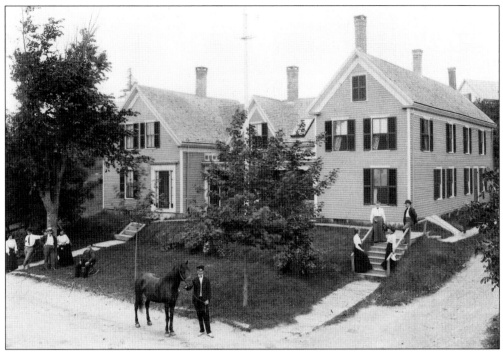

The Central Hotel was originally built as the McDonald House in about 1871. By 1889, it was owned by Elbridge Pendleton. In the 1960s, it was torn down to make way for the fire station and town office. The hotel's registers from the late 1880s and 1890s give a wonderful picture of the guests: entertainment troupes, business men, "drummers," Burton's $10,000 Dog Circus, Heinz pickle salesmen, labor union leaders, and people from San Francisco, Alaska, and Tokyo, Japan.

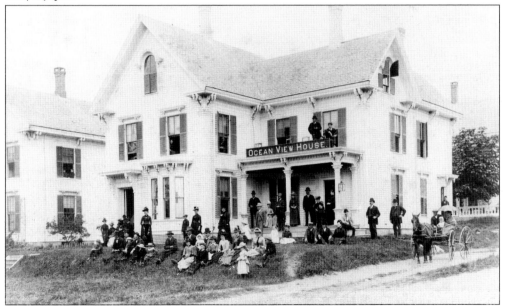

Ocean View House, under proprietorship of Joseph F. Hopkins, is shown with 1889 Centennial Day guests watching the festivities. The hotel later became The Down Easter.

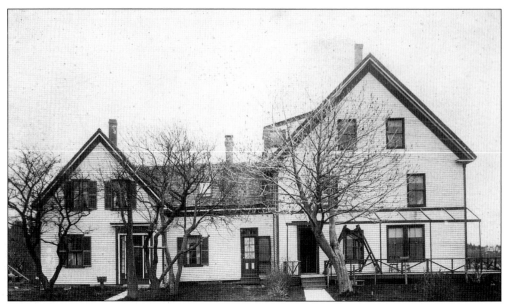

For seventy-five years from the turn of the century, Bridgeside Inn (shown here in about 1915) was a popular summer vacation spot for teachers, artists, and families. Many people spent the whole summer and returned year after year. Emeline Roberts was the owner and proprietor until the 1940s.

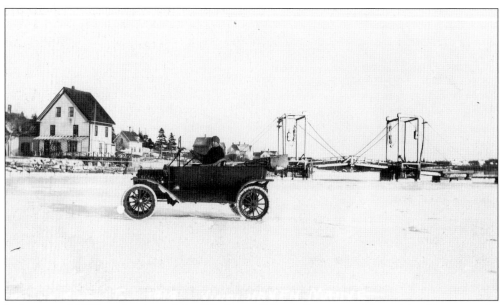

In January of 1918, at the time of the "Big Freeze," Frank Beggs was able to drive his car on the harbor. He is shown here near Bridgeside Inn and the Lane's Island drawbridge.

The Lane home, on Lane's Island, was run by Francis Lane from 1874 to 1891 as the Ocean House. Part of the original building was removed and it was run as "Rockaway Inn," a summer hotel, from the late 1920s until the mid-1950s. A piazza with two-story columns and a brick terrace was added. The columns proved unsatisfactory and were removed before 1940.

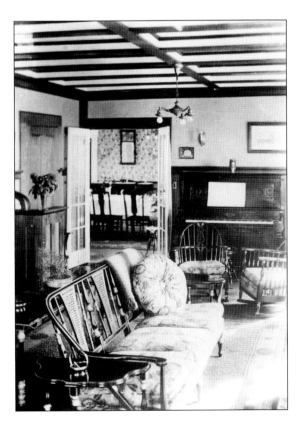

This image shows part of the parlor and a bit of the dining room through the French doors.

VINALHAVEN HIGH
Athletic Association

BASEBALL SCHEDULE
1915

V

J. F. HEADLEY, Mgr. '15

R. A. BURNS, Capt. '15

April

24-Castine at
VINALHAVEN

May

1-Rockland at
VINALHAVEN

8-Vinalhaven at
THOMASTON

13-U. of Maine Law at
VINALHAVEN

15-Thomaston at
VINALHAVEN

22-Vinalhaven at
CAMDEN

29-Locals vs V. H. S.

31-Vinalhaven at
BELFAST

June

1-Vinalhaven at
CASTINE

5-Vinalhaven at
ROCKLAND

9-Camden at
VINALHAVEN

12-Belfast at
VINALHAVEN

The ball field next to the White School, with the high school beyond, was used by organized baseball teams from the high school and the town. The schedule above shows the teams played by the school in 1915.

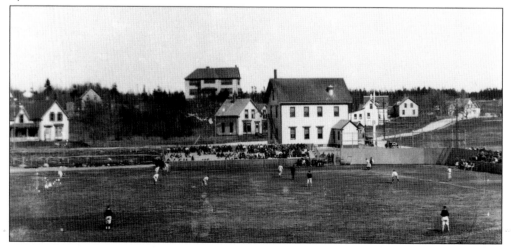

Seven

Sports and Recreation

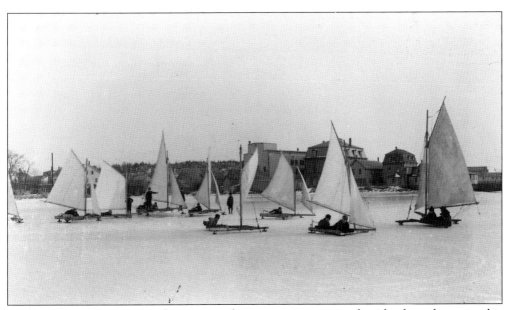

Ice boating on Carver's Pond was a popular winter pastime on the island, as shown in this photograph from 1897. Now, at the end of the twentieth century, ice boats have returned to Carver's Pond.

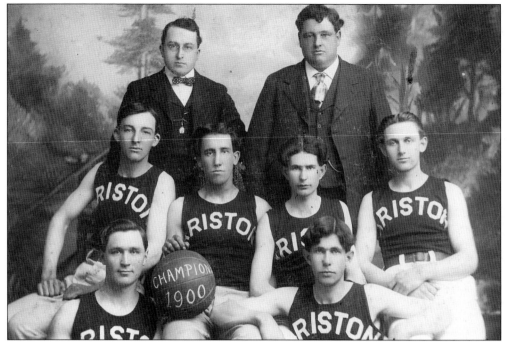

The Ariston Club was organized on October 4, 1897, and rented the town hall for a court. The first basketball game was played on December 1, 1898. Teams from the mainland were the club's opponents, and in 1900 the Aristons won the championship.

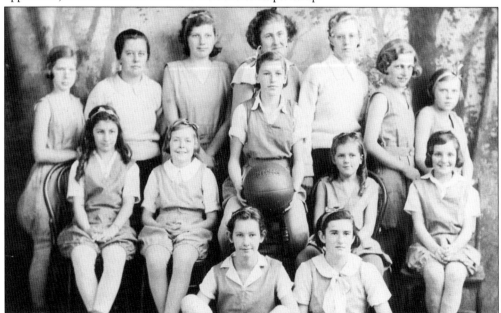

This photograph shows a 1930s Vinalhaven School girls basketball team. From left to right are: (front row) Carolyn Dyer and Eleanor Calderwood; (middle row) Louise Burgess, Betty Brown, Lois Webster, Jean Strachan, and Marion Littlefield; (back row) Miriam Greenleaf, Natalie Smith, Corinne Greenleaf, Olive Amiro, Elizabeth Gray, Marion Tolman (Pendleton), and Dolly Dunlap.

106

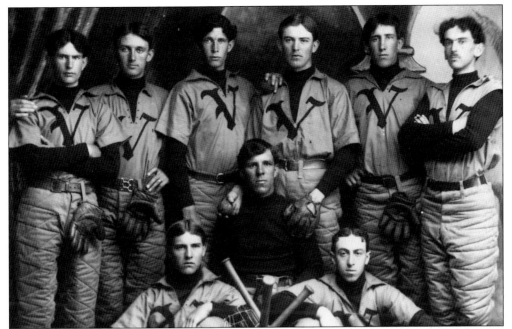

The Vinalhaven Reds were the outstanding local baseball team in 1900, playing in the Knox County League. Shown here, from left to right, are: (front row) Bert Boman and Babbin Fifield; (middle) John Geary; (back row) Link Sanborn, Ben Smith, Harry Sanborn, Charlie Boman, Tat Mills, and Arthur Vinal. The local baseball fever was so strong that the team became semi-professional, with imported players added.

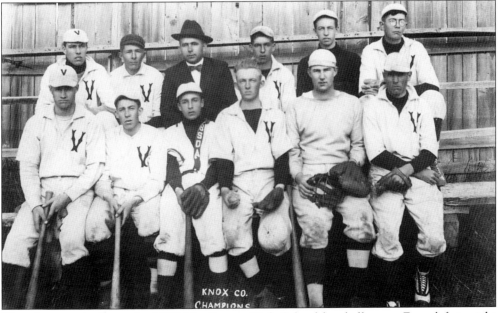

This photograph shows the 1920 Vinalhaven High School baseball team. From left to right are: (front row) Maurice Bickford, Carol Burns, James Smith, Lester Mullen, Don Patterson, and Ken Raymond; (back row) Sawin Pierce, Roy Ames, Coach Smith Hopkins, Herb Patrick, Alfred Hall, and Leon Arey.

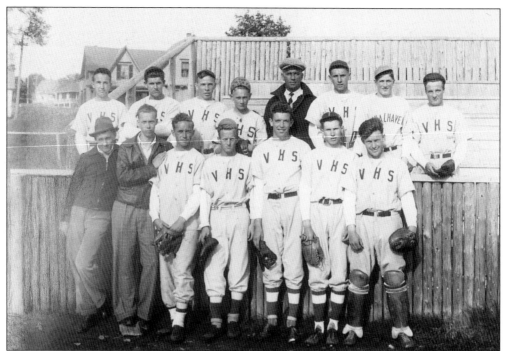

Here we see Vinalhaven High School's 1938 champion baseball team. From left to right are: (front row) Hollis Burgess, George Headley, Raymond Alley, Stan Conway, Phil Brown, Frank Peterson, and Tim Erickson; (back row) Ducky Haskell, Earl Hamilton, Randolph Robinson, Bert Dyer, Coach Herb Patrick, Norman "Crow" Johnson, John Chilles, and Bob Littlefield.

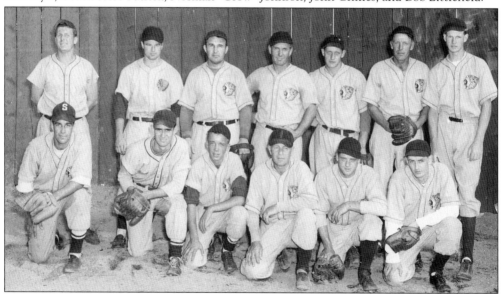

The Vinalhaven Chiefs, the town team from the 1930s to the 1950s, is shown here in 1949. From left to right are: (front row) Brud Carver, Joe Plante, Hinky Davis, Ed White, Herb Conway, and Wyvern Winslow; (back row) Angus Parker, Sonny Oakes, Ducky Haskell, Wyman Guilford, Bud Mitchell, Fred Swanson, and Hokey Gustavson. The Chiefs played such teams as the Rockland Pirates, the Warren Tigers, and the Boston Royal Giants.

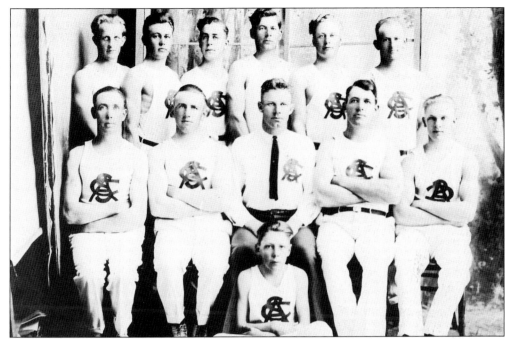

In the early 1900s, a number of men from Scandinavia came to work in the paving quarries. By 1924, when this picture was taken, they had joined together to form their own Scandinavian Athletic Club. In at least one parade, they rode on the back of a truck doing gymnastics. From left to right are: (front row) Fritz Swanson, Oscar Swanson, Einar Carlson, Gustave Swanson, and Birger Youngquist, with mascot Fred Swanson on the floor; (back row) Frank Youngquist, Eric Johnson, "Little Gus" Swanson, Arthur Malmstrom, Jack Carlsen, and Gus Skoog.

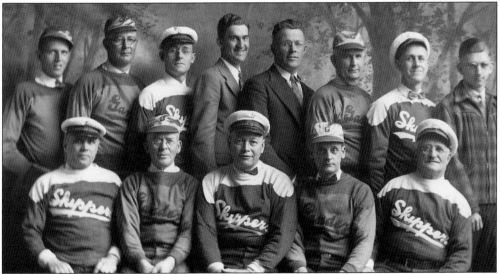

The Bowling Alley on Main Street was very popular. Two of the teams, the Ganders and the Skippers, are shown here in the mid-1930s. From left to right are: (front row) Ambrose Peterson Sr., "Spider" Grimes, O.V. Drew, Scott Littlefield, and Eugene Hall; (back row) Vic Shields, "Goose" Arey, Les Dyer Sr., Walter Lyford, Everett Libby, "Link" Sanborn, "Skip" Arey, and Harve Tolman.

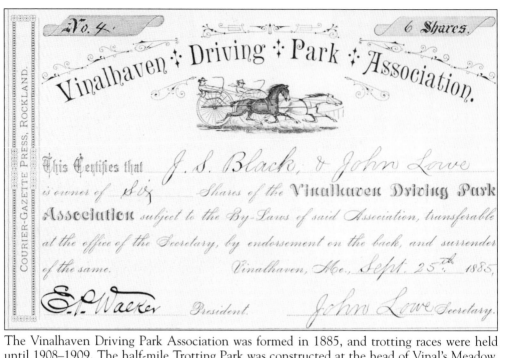

No. 4. 6 Shares.

Vinalhaven ✛ Driving ✛ Park ✛ Association.

This Certifies that *J. S. Black, & John Lowe* is owner of *Six* Shares of the **Vinalhaven Driving Park Association** subject to the By-Laws of said Association, transferable at the office of the Secretary, by endorsement on the back, and surrender of the same. Vinalhaven, Me., *Sept. 25th 1885,*

E. P. Walker President. *John Lowe* Secretary.

The Vinalhaven Driving Park Association was formed in 1885, and trotting races were held until 1908–1909. The half-mile Trotting Park was constructed at the head of Vinal's Meadow. Horses were brought from Belfast, Bangor, and other mainland towns to race against the island horses.

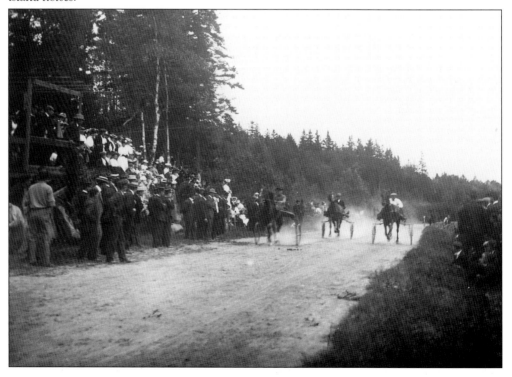

On Sunday afternoons, croquet was a favorite recreation of the older members of this family. They owned the vacation home, Rock Cottage, located in town near the Washington School. The bicycle, called a safety bike, was introduced to the island in 1892.

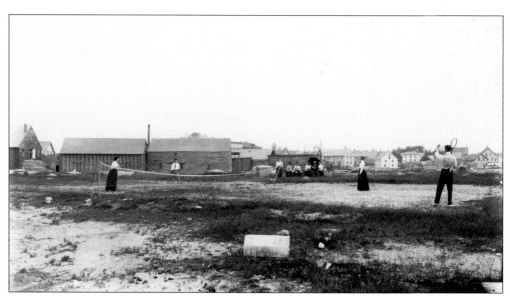

In this photograph, taken around 1910, this group has taken advantage of a fairly level spot by the harbor to set up a tennis game.

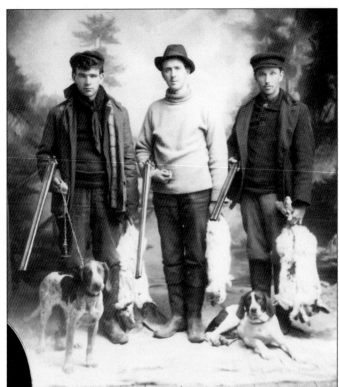

In the winter, hunting was a popular sport. The young men in this image were proud enough of their dogs and their catch to go to Merrithew's studio for this "portrait."

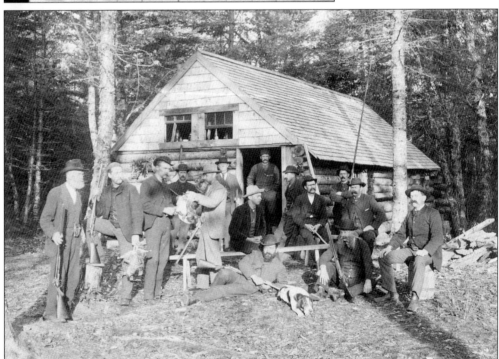

As this early 1880s picture shows, hunting for game birds was also popular. There were a number of privately owned hunting camps on the island.

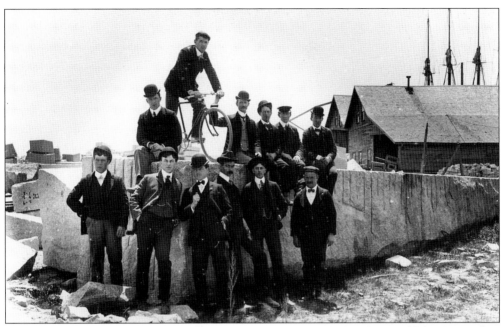

The quarrymen worked a six-day week, so Sunday was the only day they could dress up and go to the quarry for a lark. This photograph was taken at the stone rejected for the General Wool Monument (see p. 19) that still lies by Sands Cove Road. Another group was photographed by Dr. B. Lake Noyes of Stonington while visiting the famous granite eagles in 1898 (see p. 24).

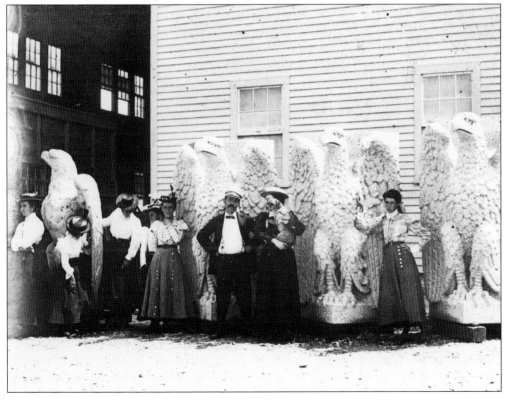

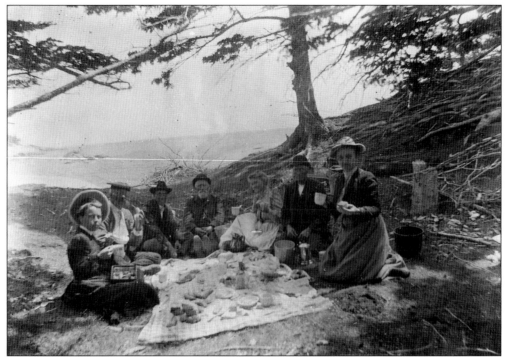

In 1904, this group of friends enjoyed a picnic on Green's Island near Heron Neck Light House.

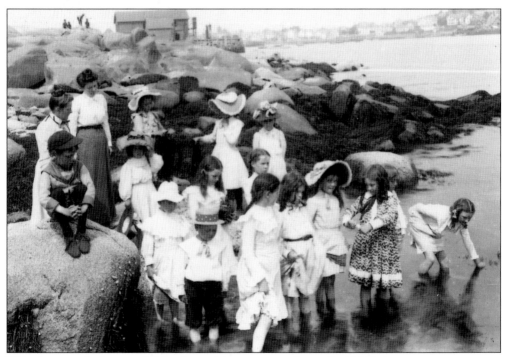

This photograph shows a children's party on a summer day at Smith's Point.

Eight

People and Places 'Round the Island

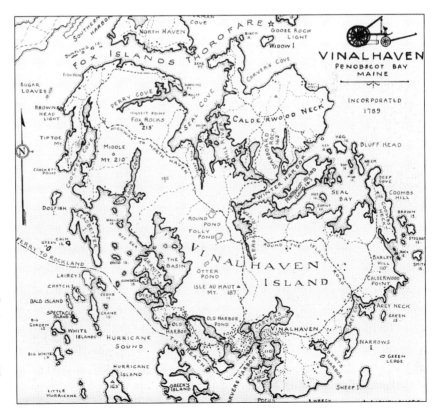

This map of Vinalhaven is more detailed then the one on p. 2, and it gives the viewer a good sense of the island's size.

The road from Carver's Harbor to the north end of the island branches at a spot known as "The Sign Post." The right-hand fork goes to Calderwood's Neck, and the left goes through Zion to the Fox Islands Thorofare.

The body of water known as "Round Pond" is shown here with the north-south road running by it. The pond has served several purposes: it's been used as a recreational site with boats, a dock, and a cabin, all provided by Moses Webster; it's provided ice in the winter; and it's served as one of the sources of the town's water supply.

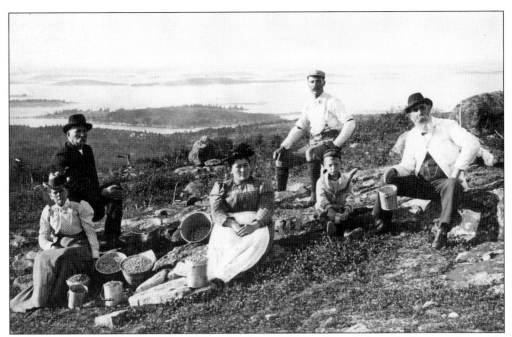

The Job Tolman family, the John Moore family, and Rufus Coombs have had a very successful day picking blueberries. They are possibly on Middle Mountain.

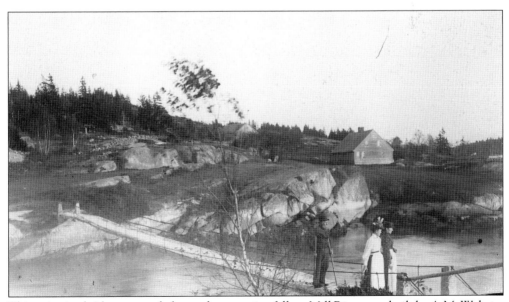

This swinging bridge, suspended over the reversing falls at Mill River, was built by A.M. Webster using cable from his quarry at Pleasant River. Almond Hall lived on one side of the falls and his father-in-law, Cyrus Calderwood, on the other.

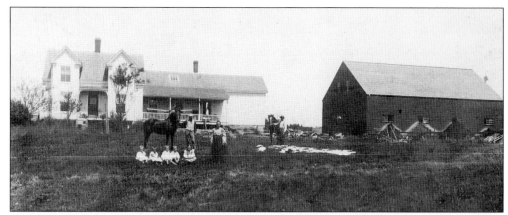

The above farm, located at Mill River, came into the hands of the Greene family in 1837. Robert Franklin Greene, who was born on the farm in 1858, married Edith Nichols in 1891. That same year he started the daily delivery of Evergreen Farm milk to many island homes. The picture below shows the family with five children, all of whom attended Bates College.

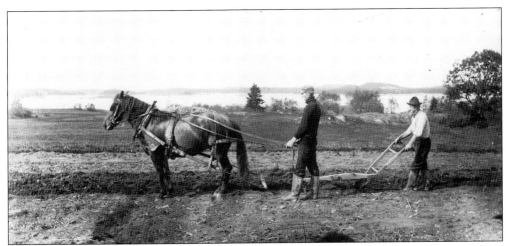

This photograph shows another farm, on Coombs Neck, in about 1905. Benny Coombs and his son Lyford are plowing their field.

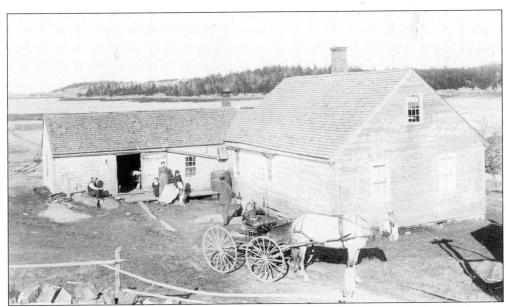

Anthony Smith bought this farm on Seal Bay in 1837. Sarah Elizabeth, who was known affectionately by all as "Aunt Sarah Liz," lived here for many years. She often took the family's produce into town in the wagon that is shown in this early picture.

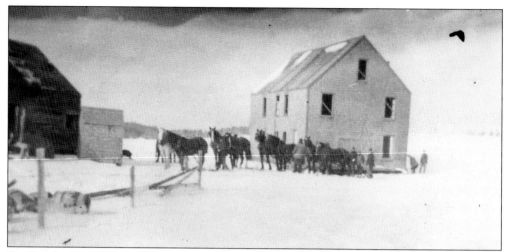

On October 23, 1908, the Pleasant River Grange was officially organized at the Watson H. Vinal homestead. When Captain A.M. Webster closed his granite quarry on the shore of Pleasant River, he donated the former quarry boarding house to the Grange. This photograph shows the building being skidded by horses along Pleasant River to its new site.

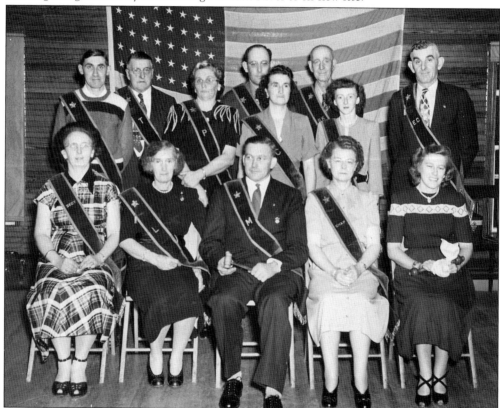

The officers of the Grange are being inducted in this 1950 picture. From left to right are: (front row) Florence Lawson, Winnie Ames, Curtis Webster, Alice Whittington, and Lois Webster; (back row) Gerald Mossman, Mel Smith, Albra Whittington, Roy Dyer, Leola Smith, Herbert Calderwood, Charlotte Coombs, and George Wright.

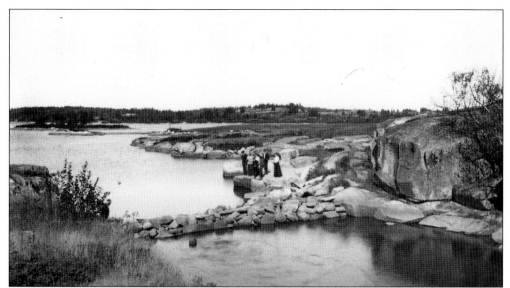

This family is fishing on a summer Sunday. They are by "The Dyke" at Vinal's Falls, on Pleasant River, a spot which is near the Grange.

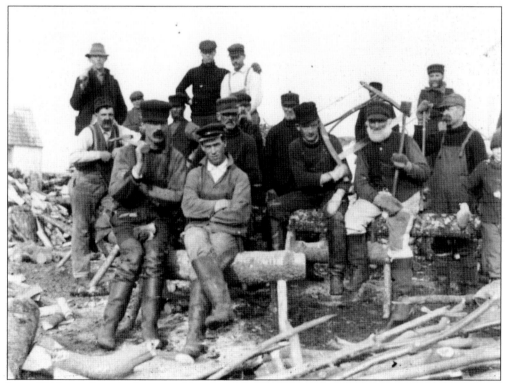

Lucy Hildings described events like the one in this picture as follows: "We used to have woodchoppings. Farmers would get out eight or ten cords of wood. All the neighbors around came. The men all chopped and split the wood. At supper time the woman put on a baked bean supper. We'd have a [kitchen] dance in the evening. Everyone had fun."

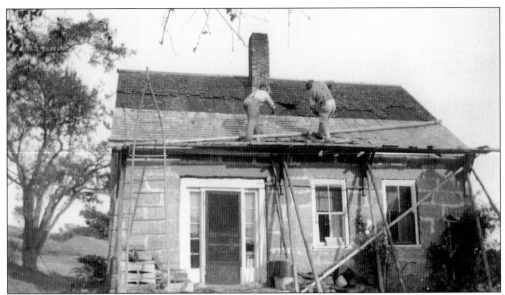

In the 1850s, Isaac Murch and his father built the only granite home on the island, at Pleasant River, Calderwood Neck. They built the house from blocks that were quarried nearby. Lieutenant Isaac Murch was killed at Donaldsonville, Louisiana, during the Civil War, but his descendants continued to live there. Shown here are brothers Frelon and Fred Murch, reshingling the roof one hundred years later.

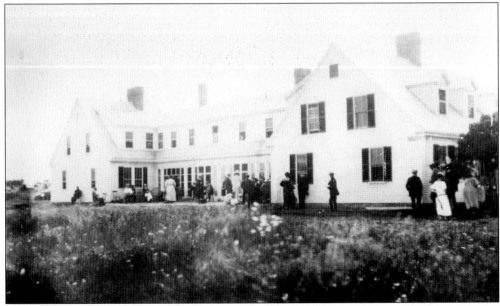

The property on Calderwood Neck known as Eastholm was first owned by James Calderwood, who then passed it on to his son Jasper. In 1923, it was purchased by Mr. and Mrs. Alton Roberts of Marquette, Michigan, who converted the old farmhouse to a beautiful summer home. Mrs. Roberts often invited islanders to parties, and the people shown here are even peeking in the windows to see the improvements.

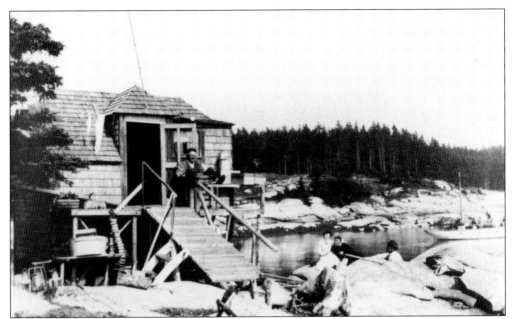

This 1920s photograph shows James Harvey Ames at his lobster shack in Lobster Cove, on Leadbetter's Island. He maintained a pound and sold lobsters to visiting yachtsmen.

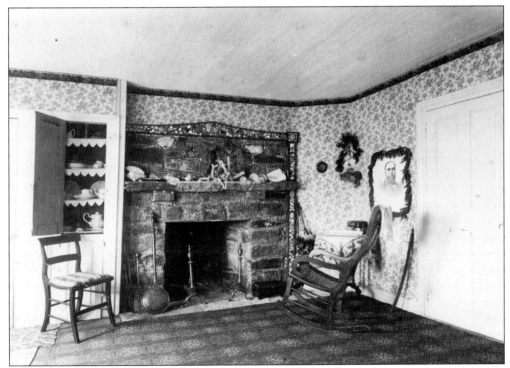

The interior of the Kimball home on Leadbetter's Island includes a picture, surrounded by evergreens, of the late Joseph R. Bodwell, who had served as president of the Bodwell Granite Company (1871–1887) and as governor of Maine (1886–1887).

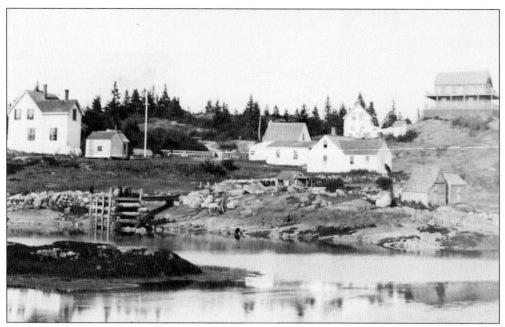

On the west side of the island, near Old Harbor, is Squid Cove. To the left are the former Ira O. Allen home, the house known as the Shoe (from the nursery rhyme), and on the hill is the Bungalow, which at one time was a dance hall.

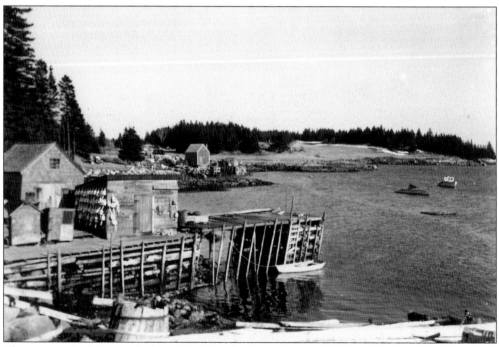

This picture, looking south down The Reach, shows Herman Holbrook's wharf, the wharf and fishhouses of the Brays, and then the Ames farm.

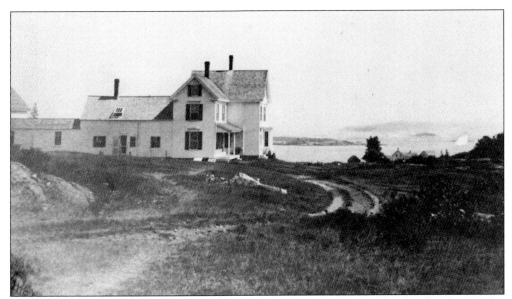

The Captain Elisha Roberts farm, at Roberts Harbor, was purchased by Franz Herrmann, the New York agent of a German marine insurance company. Herrmann hired many island residents to remodel the shore house and to create new buildings, including a large greenhouse, several barns, a boathouse, and extensive gardens. Herrmann died in 1921; only a caretaker lived on the property until 1936, when it was purchased by Dr. Paluel Flagg of Yonkers, New York.

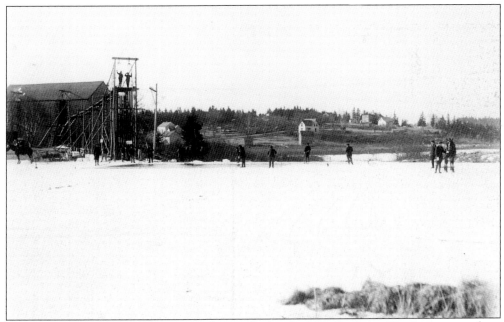

For many years, a large icehouse stood near the head of Sand's Cove. The ice was cut from Old Harbor Pond in 250-pound blocks, hoisted up to the chute, and moved into the icehouse, where it was then packed in sawdust. Not only was ice provided for island homes and businesses, but there was a long slide on the harbor side where ice was loaded onto vessels and shipped to other communities.

In September of 1947, a group from Hollywood arrived in Vinalhaven to film the movie *Deep Waters*. The movie was a Twentieth Century Fox production, directed by Henry King, that was based on the Ruth Moore novel, *Spoonhandle*. The stars were Dana Andrews, Jean Peters, Cesar Romero, Ann Revere, Ed Begley, and Dean Stockwell. A number of local residents had bit parts, were technical advisors and stand-ins, housed the film crew, or just hung around the set to watch.

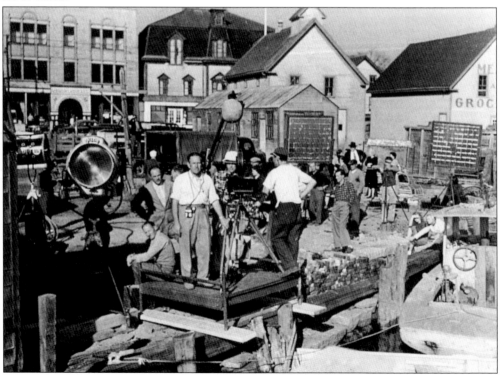

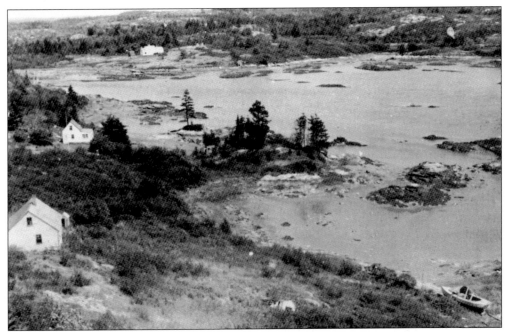

The Crockett's River area is a scenic part of the island and is viewed here from "Tip Toe Mountain." The below view from "Tip Toe" is to the west and looks across the Thorofare to Crabtree Point on North Haven and to the Camden Hills beyond.

Acknowledgments

We are grateful to the many families who, over the years, have generously given photographs to the Vinalhaven Historical Society for its collection. We also appreciate the assistance of society members, especially the museum's curator, Priscilla Rosen.

Many of the photographs in this volume are from our William H. Merrithew Collection, including those used for our 1996–97 exhibit, *The Photographer as Historian*, printed by Tillman Crane, and supported by a grant from the Maine Humanities Council. The portrait of John Vinall by John Mason Furness is reproduced with the permission of the Dick S. Ramsay Fund of The Brooklyn Museum. Access to other photographs came from the Maine Historic Preservation Commission, Afton Stenger, and Frank E. Claes.

Photographers who have made prints for us are Alice Bissell, Paulette Barton of the Penobscot Marine Museum, Roderick Hook of Imageworkers, and Roy Wells of Wells Photographic.